IMAGES
of America

# FILIPINOS IN
# HOUSTON

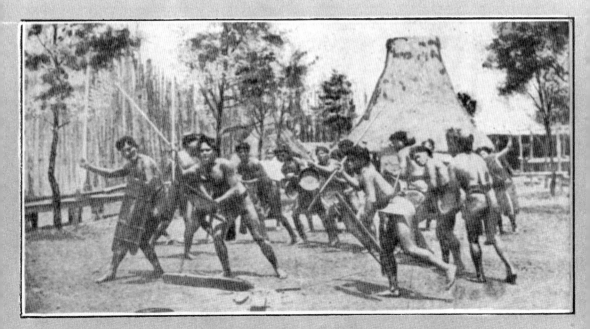

Igorrote Village, Midway, No-Tsu-Oh Carnival November 9 to 14. 1908

**THE NO-TSU-OH FESTIVAL.** No-Tsu-Oh (Houston spelled backwards) was the title of a festival that promoted Houston as an agricultural city. One sideshow included a display of Philippine natives known as Igorotte (meaning "mountain people"). The festival started in 1899 and halted following the publishing of a critical newspaper article and the onset of World War I. (Courtesy of the Houston Metropolitan Research Center of the Houston Public Library.)

**ON THE COVER:** Filipinos started to come to Houston in large numbers in the mid-1960s due to a change in immigration law. Most were registered nurses, recruited in the Philippines. Many had never ventured out of the country before. Communities were small, supported each other, and acted as adopted families. A well-dressed group is pictured here in downtown Houston. (Courtesy of the Guevara family.)

IMAGES
*of America*

# FILIPINOS IN
# HOUSTON

Christy Panis Poisot and Jenah Maravilla

ARCADIA
PUBLISHING

Copyright © 2018 by Christy Panis Poisot and Jenah Maravilla
ISBN 978-1-4671-2968-8

Published by Arcadia Publishing
Charleston, South Carolina

Printed in the United States of America

Library of Congress Control Number: 2018945930

For all general information, please contact Arcadia Publishing:
Telephone 843-853-2070
Fax 843-853-0044
E-mail sales@arcadiapublishing.com
For customer service and orders:
Toll-Free 1-888-313-2665

Visit us on the Internet at www.arcadiapublishing.com

*This book is dedicated to the Filipino American*
*families and communities of Houston.*

# CONTENTS

# ACKNOWLEDGMENTS

The Filipino American National Historical Society Houston Chapter was founded in April 2015 out of a growing need to document the story of the Filipinos in Houston. Meriendas were held to connect with the community and collect these stories.

Anthony Guevara and Patlindsay Catalla are acknowledged for their contributions to the *Filipinos in Houston* book.

To Lieszl Compas, the late nights of writing captions, scanning photographs, and eating corned beef and eggs with Dolly Echiverri and Gilda Dimayuga are among my fondest memories.

To Pilipino American Unity for Progress (UNIPRO), who cohosted our Meriendas. Special thanks to Jenah Maravilla, who helped organize and write the captions that make the stories of this book. I hope she can use this experience to write the stories she is meant to tell in her lifetime.

To the Organization of Chinese Americans (OCA), especially Debbie Chen, Cecil Fong, and Rogene Calvert, Steven Wu, and State Rep. Gene Wu for your community collaborations and shared moments of intersecting histories and activism. The Chao Center for Asian Studies, especially Anne Chao and Amanda Focke, for providing FANHS-HTX with a framework to lecture and archive stories and artifacts for the Filipino Americans of Houston. To Donna Fujimoto Cole and Maj. Gen. Tony Taguba (Ret.), my mentors, we are kindred spirits in our shared passion for veterans, the greater good, and the betterment of the Asian American community.

To the community of Houston Filipinos who shared their stories and photographs to make this book, especially Florencio Guinhawa, Tito Refi, Joanna Po, and Manolo DePerio. I apologize to anyone we may have forgotten.

Thank you to Arcadia Publishing for providing an avenue for this documentation to take place and for title manager Stacia Bannerman, who reminded me of deadlines and gave advice.

I am grateful to my entire family, especially my love, Andre Poisot, and our children for allowing me to share our family time with many people. My hope is that our children, in some way, view this book as a portal into connecting their identities, and are inspired by the endless possibilities for making a difference in the world.

—Christy Panis Poisot
2018 Filipino American National Historical Society President–Houston Chapter

# INTRODUCTION

Filipinos have been in Texas much longer than most may realize. The Manila Galleons made annual trips between Manila and Acapulco from 1565 to 1815. Cultural exchanges, as well as Asian goods, were traded between the Gulf of Mexico and the Texas coastline, which made it very likely that Houston was one of the stops for commerce with the Spanish. According to *Asian Texans* by Irwin Tang, the first Filipino in Texas was Francisco Flores. He was born in the Philippines and worked on a Spanish schooner involved in the slave trade. Flores saved enough money to buy his own boats to fish and trade along the Texas coastline. He eventually settled in Rockport, Texas, two hours from Houston. He died at the age of 108 in 1917.

Another migration of Filipinos to Texas began after the Spanish-American War. Philippine officers working for American soldiers came to Texas as US nationals, since the Philippines was a new territory of the United States. The census showed six Filipinos were living in Texas in 1910, and by 1920 there were thirty. Filipinos who managed to make their way to Houston in the early 1900s were part of a student exchange program, the Pensionado Act of 1903, which allowed qualified Filipino students to study in the United States to learn the workings of American government and then return to work in the Philippine government. There were 103 students in the first wave of pensionados, including Rudolfo Hulen Fernandez, the first Asian graduate of Rice University, according to Centennial Historian Melissa Kean in Rice University's *Rice History Corner*. Not many Filipinos were in Houston at all after Fernandez until the change in immigration law. The 1930 census documented 288 Filipinos in Texas. The decreased rate was due to the Tydings-McDuffie Act, otherwise known as the Philippine Independence Act, which limited the number of Filipinos allowed to enter the United States to 50 per year. After World War II, the few Filipino military families in Texas lived in or around military bases such as Fort Bliss in El Paso or Fort Hood in Killeen. This included Filipina war brides of American and Filipino American servicemen who married during World War II or after.

The Immigration and Nationality Act of 1965 abolished the quota system. According to Tang, the Filipino Texan population was 3,442—with the ratio favoring women. In Houston, there were 326 women to 254 men, a ratio of 1.3 to 1. The gender imbalance continued in 1990, with 72 men to 100 women. Initially, the women and men lived in separate communities as groups of Filipino nurses went to nursing school in the Philippines together, were hired together, and lived together. Many nurses were recruited by Lourdes Dumlao, the owner of the Karilagan Travel Agency. The agency specialized in the placement of many nurses and physical therapists to Houston.

Nurses had to return to the Philippines after two years if they came under the Exchange Visitor Program. As the women came, they were accompanied or followed by their significant others. Many men were highly trained engineers, architects, and accountants employed by construction companies such as Brown & Root, Fluor, and Bechtel. In these cases, they were sponsored by their employers and could earn a path to citizenship. Many of these men married nurses, who were then allowed to stay in Houston and become United States citizens as well. As a result, the small,

close-knit group of first families was established and the Filipino community began organizing. According to the *Philippine Centennial Review, One Hundred Years in the Life of a Nation*, in an article written by *Manila Headline* editor Jimmy Viray titled "Filipino American Community in Houston," the first Filipino organization was the Philippines Association of Texas (PAT) formed in 1963. Dr. James Diamonon was the first Filipino to practice in Harris County in 1959 and led the PAT in 1967. The Filipino Association of Metropolitan Houston (FAMH) formed in 1969. Its first president was Phil Reyes. Successors were Bert Patenia, Pres Aranas, Pete Bautista, Ben del Puerto, Max Pizarras, Toti Concepcion, Dodi Gallardo, Tom Amaba, Romy Crisostomo, and Tony Garcia. The Filipino American Society of Texas (FAST) formed in 1979. Presidents were Rafael Navo, Federico Villamayor, Bob Marukot, Norma Benzon, Pepito Beltran, Noel Carino, Domie Perdido, Billy Vergara, Frank Libuano, Babbie Piniones, Tito Refi, Ernie Abadejos, Rudy Gonzales, Jimmy La Guardia, Nito Acupan, Paquito Cauli, Ben Tolentonio, and Nick Castillon. FAMH, at its peak, centered its activities on counting and welcoming all Filipinos to Houston at the airport and fostering community growth. Romy Ronquillo, a veteran community leader, said, "We were united in community functions. Every family knew each other, the reason being that we belonged to only one organization—FAMH." FAMH and FAST were considered the first core Filipino organizations and spawned many other community organizations.

The census showed an increase of migration between the years 1950 and 2000. The number of Filipino Americans in Texas went from 4,000 to 75,226, the seventh-largest population of Filipino immigrants in the country. By 2011, five percent (86,400) of all Filipino immigrants in the United States lived in Texas. The census story is a microcosm of what was playing out in the Houston narrative of the nurses and professional migration within Houston.

The story of settlement of Filipinos in Houston can be tracked by where families worked. Since many jobs were initially sourced in the Texas Medical Center in the 1960s and early 1970s, residential options for immigrants began with apartment housing near the hospitals—within walking distance or by bus transport. For example, many young married couples, young families, and singles shared photographs of their first addresses in Houston in and around South Braeswood and Holcombe Boulevard, downtown Houston, and the Hiram Clarke area. As families established themselves in Houston and the population grew, so did the desire for better and bigger living conditions. Many Filipinos looked to Southwest Houston, where housing development booms fulfilled the need. Northwest Houston was where many accountants and doctors settled.

Grandparents reunited with growing families in the 1970s and 1980s to help with childcare. First the grandmothers (*lolas*) came, and then the grandfathers (*lolos*), many of whom were aging World War II Filipino veterans who found themselves looking for compensation for their wartime service to help them in their senior years. In February 2009, the World War II Filipino Veterans Equity Compensation (FVEC) Fund was established (with the help of local advocates such as Anthony Guevara and Bobby Reyes), and even more veterans came to claim the onetime settlement. In December 2016, the Filipino Veterans of World War II Congressional Gold Medal Act of 2015 was passed. Two living veterans, Moises Hortaleza and Eduardo Javelosa, along with other veterans honored posthumously, were recognized in a Houston ceremony at the Lone Star Flight Museum on January 27, 2018.

Hidden stories of the Filipino community in Houston have been brought to light through articles members of the community wrote about themselves in pamphlets and booklets sold at galas for fundraising, with the donated images being shared. We officially record these for future generations to find inspiration for their own identities as they continue to make Houston history.

# One

# TEXAS HISTORY
## FIRST FILIPINO IN HOUSTON

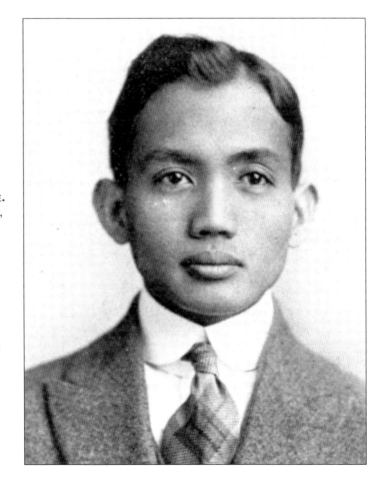

**FIRST FILIPINO GRADUATE.** Rudolfo Hulen Fernandez, a Filipino who entered with the first Rice University matriculating class in 1912, was the school's first Asian American Filipino. He graduated in 1917 and followed a highly unusual path from the Philippines to Houston's own Rice University. His story was published in an article in Rice University's *Rice History Corner* by Centennial Historian Melissa Kean. (Courtesy of Rice University.)

# THE RICEONIAN LITERARY AND DEBATING SOCIETY

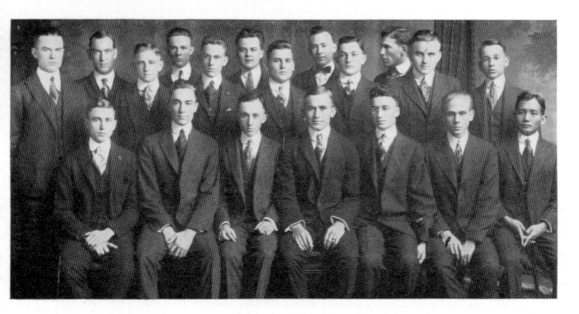

TOP ROW:  WEST, BRADLEY, KRAUSE, HAMILTON, HANNA, MILLER, RUDD, GERHARDT, GANGLER, GRAY, TAYLOR, MERRICK
BOTTOM ROW:  EGGERS, WHITAKER, MARKHAM, BULBROOK, NILAND, RILEY, FERNANDEZ

A CIRCUITOUS PATH. Rudolfo Hulen Fernandez is pictured in the Rice University yearbook, the *Campanile*, in 1914 on the first row, far right in this image of the literary and debating society. During the war, Fernandez was an interpreter for Capt. (later Gen.) John A. Hulen of the 33rd US Infantry, stationed at Narvacan. Hulen was impressed with Fernandez and adopted him, bringing him back to Texas. (Courtesy of Rice University.)

## BLENDING OF EAST AND WEST

### RUDOLFO HULEN FERNANDEZ

Mr. Fernandez, who writes this story for the *Texaco Star*, is a student in the Senior Class of the Rice Institute. Born in the Philippines, he served, although then a mere boy, as Interpreter for General John A. Hulen through both military activities and civil administration. In 1901 he came to this country with General Hulen who legally adopted him as a son.

The English are rather conceited in their opinion that they are the only people who can govern the East. They tell us, who have been forced to bear the responsibilities of westernizing the Philippines, that it is impossible to plant Western ideas among Eastern people. They seem to forget that the Spanish character, with its strain of orientalism, its fertility of resource in meeting new conditions, its adaptability in dealing with the dwellers of warmer lands, had already played its part when we annexed the archipelago, thus paving the first path of Western ideas into the East.

We found the system of government a simple one in its essential features. The missionary priest had taught the people the Faith, laying stress upon the fear of God and reconciling the people to their subjection by inculcating the Christian virtues of patience and humility. When recalcitrants refused to accept the new order, or showed inclination to break away from it, the military forces, acting under the secret direction of the priest, made raids in the disaffected parts; but after sufficient punishment had been inflicted and a wholesome fear inspired, the priest opportunely interfered in behalf of the natives, by which means the native was convinced that peace and security lay in submission to authority. It was, therefore, amazing how eagerly the native took advantage of the American public school system. More than nine thousand natives are now teaching the English language. We have supplanted the old Spanish ideas with American institutions and learning, and peace and prosperity reign throughout the Islands, from mountain fastness to the crowded streets of the cities.

But let us not forget that what we have done in the short time of eighteen years has been accomplished by the American administrator, who 'can keep his head when all about him are losing theirs and blaming it on him; who can wait and not be tired by waiting, or being lied about, don't deal in lies; who can bear to hear the truth he has spoken twisted by knaves to make a trap for fools; and who could watch the things he gave his life to broken, and stoop and build them up again with worn-out tools.'

One of these faithful administrators was Alton McBlair, assistant to the chief of the Bureau of Education of the Philippine Islands. Previous to his coming to these Islands he was an instructor in philosophy in Columbia University. There he had taught many young Filipinos, whose friendship and confidence he had won. Among the girls he had taught was Lola Fortuna, the only daughter of a rich Spanish planter. To make a romantic tale short, he had fallen in love with the pretty Oriental maid, and soon after he landed at Manila they were married.

When the Democratic party came in power, and the Republicans in office were dismissed, Alton McBlair did not return to his native country, but remained in the Philippines to manage his wife's estate. Señora Fortuna had died before Lola went to the United States to study, and the daughter was the mistress of the *hacienda*. Being master of the mistress and having no punctilious mother-in-law to please, McBlair made the fields bloom like the rose. He substituted gasoline tractors for the *carabao*; a threshing machine separated the rice kernel from the hull; a modern sugar mill squeezed the juice of the sugar cane. These wonderful changes so won the admiration of Señor Fortuna, that he rarely stayed at the *hacienda* and spent nearly all of his time among the politicians in Manila.

The increasing demand for sugar by European buyers made it imperative for McBlair to install new machinery. In the middle of June, therefore, accompanied by Lola and Señor Fortuna, he motored down to Manila to sail in the first steamer for the United States.

"You are an American," said Lola to her husband, as he was about to board his ship, "and many American husbands have never

**BLENDING OF EAST AND WEST.** According to *Rice Magazine*, Fernandez wrote a romantic story, "Blending of East and West," for the *Texaco Star*, a monthly journal for employees of the Texas Company (the forerunner of Texaco). "I feel that there is no great difference between the East and the West, if viewed from one human heart to another. It seems to me that they are in a process of blending," he writes in the short story about an American educator who falls in love with and then marries one of his Filipino students. While Fernandez's life after the service is not well documented, it appears his romantic story for the *Texaco Star* proved prophetic. In late 1919, he created his own "blending of East and West" and married Katharine Lefevre, who was the daughter of *Texaco Star* editor Arthur Lefevre. (Courtesy of Rice University.)

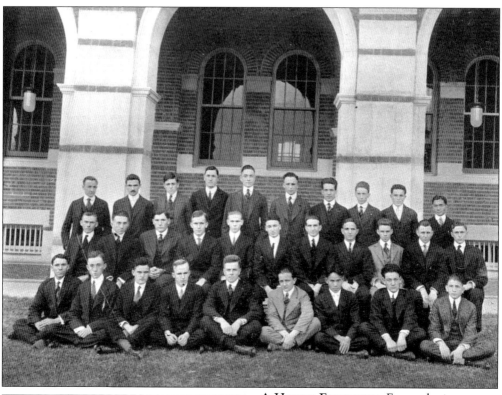

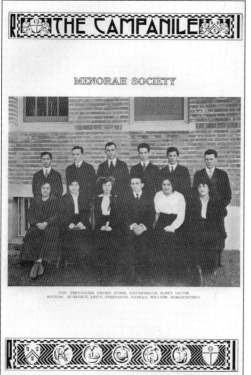

TOP: FERNANDEZ, EMDEN, ZUBER, DANNENBAUM, FLEET, VICTOR
BOTTOM: ELDRIDGE, LEVIN, STREUSAND, NATHAN, WILLNER, MORGENSTERN

**A Higher Education.** Fernandez is pictured in 1917 as part of the Riceonian Debating Society. After graduating from Rice, he reunited with his adoptive father, John A. Hulen (who was then a brigadier general), by enlisting with the American Expeditionary Forces in France and serving as his liaison. Fernandez was discharged in 1919. (Courtesy of Rice University.)

**Educational History.** Born in 1890 at Vigan, Ilocos Sur, Philippines, Rudolfo Hulen Fernandez (pictured standing at far left) was a Menorah Society member at Rice University in 1916. His father was one of the few Filipinos permitted by the king of Spain to practice law in the islands. His grandmother saw that his early education was conducted by a Franciscan priest. (Courtesy of Rice University.)

# Two

# THE JOURNEY TO VALOR
## RECOGNIZING VETERANS

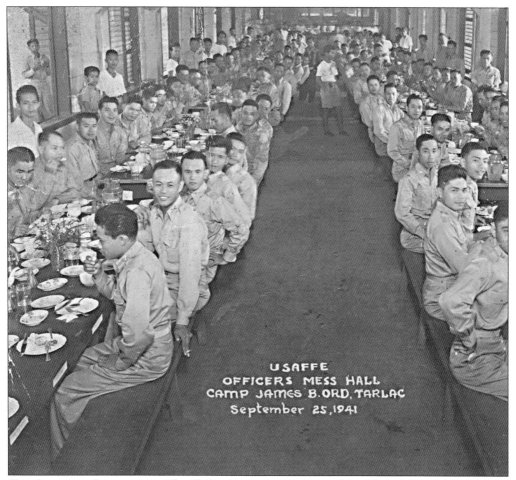

USAFFE
OFFICERS MESS HALL
CAMP JAMES B. ORD, TARLAC
September 25, 1941

THE GREATEST GENERATION. The Philippines was a territory of the United States from 1898 to 1946. The US Army Forces in the Far East (USAFFE) was made up of Filipinos inducted into the US Army and active from 1941 to 1946 during World War II, by order of Pres. Franklin D. Roosevelt. Many Filipinos who came to Houston were veterans or descendants of World War II veterans. (Courtesy of Rolando Panis.)

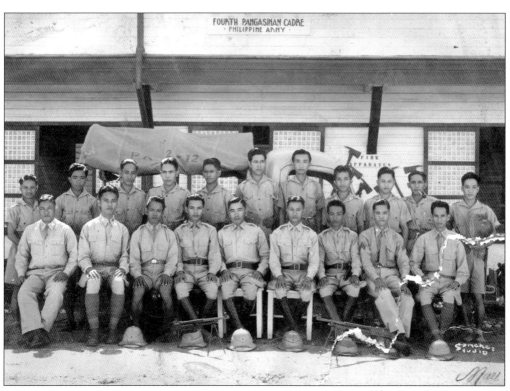

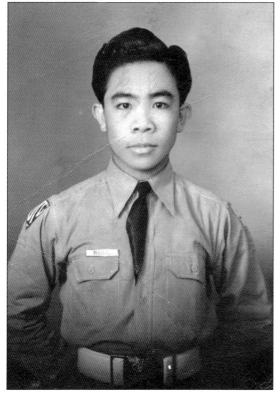

**CALL TO ARMS.** The Fourth Pangasinan Cadre was part of the Second Battalion, 23rd Infantry Regiment, 21st Division. The 21st Division insignia patch is represented by rifles crossed in the Roman numeral *XXI*. Third Lt. Signal Officer Francisco Panis (pictured second from left, second row) came to the United States in the 1990s. Many military recruits hoped to expedite immigration paperwork and receive benefits. (Courtesy of Rolando Panis.)

**CALL TO DUTY.** Third Lt. Francisco Panis was only 21 years old when he received orders to report to the 23rd Infantry regiment in Cabanatuan, Nueva Ecija, Philippines, on Sunday, August 3, 1941. On Monday, September 1, 1941, he was inducted into the US Army Forces in the Far East at Camp Ord, Tarlac, by an American officer. (Courtesy of Rolando Panis.)

**LOVE LETTERS FROM AFAR.** This photograph was found amongst love letters dated September 1941 and signed "Frankie." Francisco Panis wrote to his girlfriend Valeriana Ofiana during World War II in the Philippines. Eight months later, Panis marched in the Bataan Death March. He survived, married his girlfriend, and had four sons. Ofiana immigrated to Houston in the 1980s to help raise five grandchildren. She later became a naturalized citizen. Panis soon followed his wife to Houston in search of veteran benefits and recognition for his service. Panis was granted American citizenship upon his arrival to Houston. He never received benefits, but in 2017 he was posthumously awarded the World War II Filipino Veterans Congressional Gold Medal. His story was one of many that inspired the passage of the bill in Congress. (Both, courtesy of Rolando Panis.)

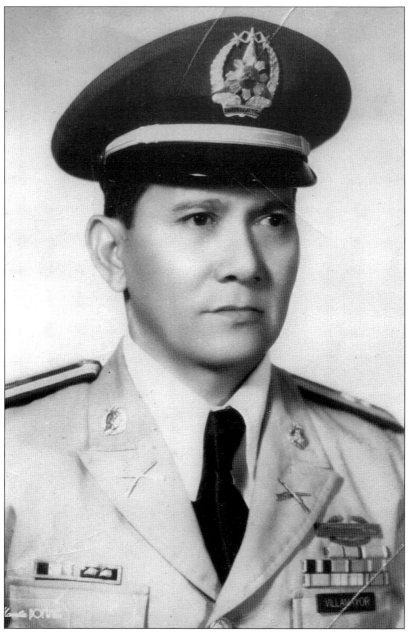

**EXPERT MARKSMAN.** First Lt. Federico Villamayor enlisted in Infanta, Tayabas, Philippines. He then became a platoon leader and earned the Philippine Liberation Badge. Villamayor was a World War II veteran who, at age 16, fought in Bataan and survived the Death March as a prisoner of war and the Japanese concentration camp at O'Donnell, Capas, Tarlac, Philippines. He joined the resistance movement and fought with the Alamo Scouts and 7th Cavalry, 1st Cavalry Division, US Sixth Army in the liberation of the Philippines. He authored the book *Ten Days to Freedom*, depicting one of his own stories of courage during World War II. First Lt. Villamayor was survived by his wife, Nora Garcia Villamayor, his seven children, 18 grandchildren, and 22 great-grandchildren. His wife accepted the World War II Filipino Veterans Congressional Gold Medal in Washington, DC, on October 25, 2017, on his behalf. (Courtesy of Nora Villamayor.)

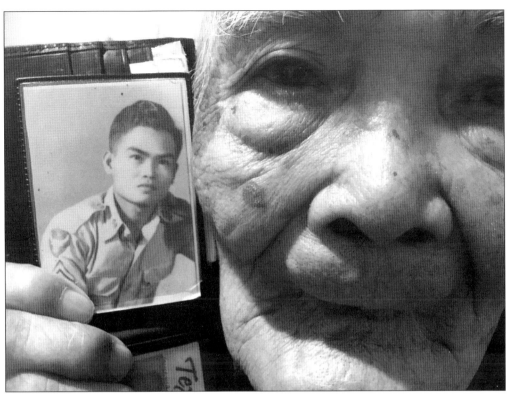

**Living History.** Moises Hortaleza was born on November 25, 1921. He served from April 1, 1942, to February 1946 as a Philippine Scout. He was honorably discharged on February 23, 1946. Hortaleza married on April 2, 1949, and had nine children. He became a United States naturalized citizen in 1992. Hortaleza is a World War II Filipino Veterans Congressional Gold Medal recipient. (Courtesy of Rechel Directo.)

**A Living Honor.** In 1942, Col. Eduardo Mendez Javelosa joined the Guerilla Headquarter Company Third Battalion 113th Infantry Operations Chief Intelligence Office, Unit I. He received the World War II Filipino Veterans Congressional Gold Medal and was interviewed by KPRC Channel 2 News. He said, "I appreciate the honor that has been given to me for the service I have done." (Courtesy of Louise Cook.)

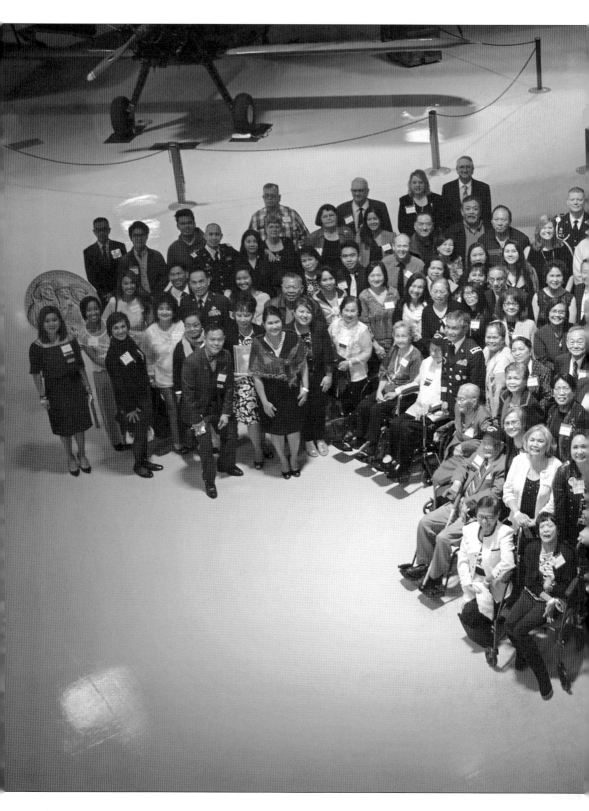

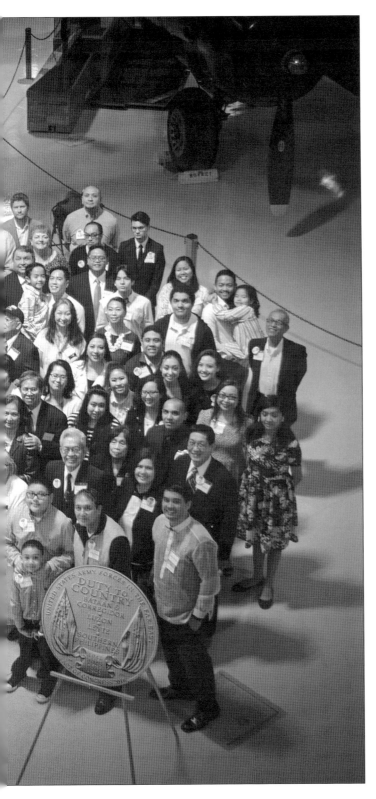

**THE HIGHEST CIVILIAN HONOR.** Approximately 140 next of kin and two living veterans attended a ceremony at the Lone Star Flight Museum on January 27, 2018, to honor 25 recipients of the World War II Filipino Veterans Congressional Gold Medal. Many Filipino veterans immigrated to Houston to reunite with their families and become American citizens, a benefit awarded to them for serving in World War II under the American flag. Congressman Pete Olson, Rep. Sheila Jackson Lee, State Rep. Gene Wu, Mayor's Office of Veterans Affairs senior outreach specialist Robert Dembo III, Maj. Gen. Antonio Taguba (Ret.), and Lt. Gen. Douglas Owens (USAF, Ret.), chief executive officer, assisted in distributing the medals. (Photograph by Trisha Morales.)

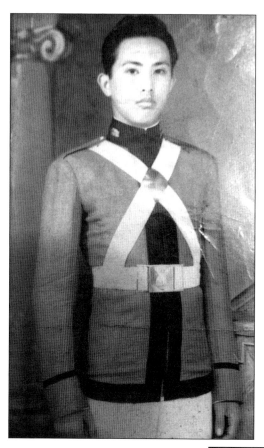

**PROUD VETERAN.** Alberto Rivera served as a member of the Philippine Commonwealth Army in the service of the armed forces of the United States from 1941 to 1945 and was honorably discharged. He was a member of the Filipino American World War II Veterans Association of Houston and a World War II Filipino Veterans Congressional Gold Medal recipient. (Courtesy of Maria Rita Rivera Jante.)

**A STORY IN A LIFE.** Ray Legaspi Burdeos was in the US Coast Guard from October 10, 1955, to March 1, 1979. He retired to Galveston, Texas, where he has written several books about his experiences. Most significant are stories of his life as a steward and lost love. He discussed his books at the 2016 Filipino American National Historical Society national conference. (Courtesy of Ray Burdeos.)

# *Three*

# FIRST FAMILIES
## SETTLING DOWN

**NOW BOARDING.**
With minimal
belongings and big
dreams, Manny
Compas, his wife,
Louella, and their
daughter Lieszl
make their way to
the jumbo jet on
the way to Houston
on March 31, 1970.
Manny is the third
Compas sibling of
11 to immigrate to
America. While
his two sisters
work in New York
City, Manny will
eventually work at
a certified public
accounting firm in
Pasadena, Texas.
(Courtesy of
Louella Compas.)

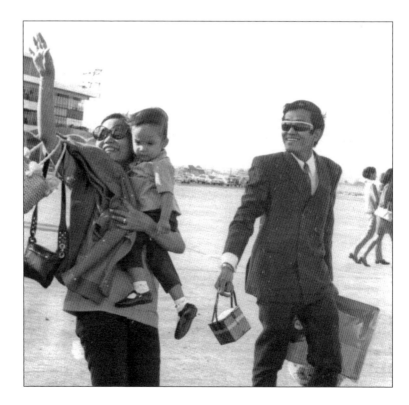

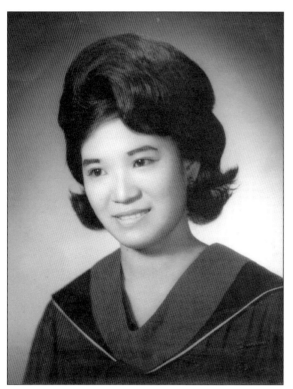

**FULFILLING A DREAM.** Jesusa Ronquillo graduated from the Philippine Women's University in 1964. Romeo and Jesusa Ronquillo are pictured with their children Michelle and Jerome. Jesusa and Romeo married in 1964 and came to the United States in 1969. Romeo worked for Mitchell Oil and Energy as a certified public accountant from 1969 to 1996. Jesusa was with Memorial Southwest Hospital in Houston from 1969 to 2001. Jerome pursued a career in mass communications, and Michelle became a registered nurse. The couple came to the United States after Congress passed the 1965 Immigration and Nationality Act, which facilitated ease of entry for skilled Filipino laborers. The act raised the quota of Eastern Hemisphere countries, including the Philippines, to 20,000 a year. The Ronquillo family was active with the Ilocano Club. (Both, courtesy of Jesusa Ronquillo.)

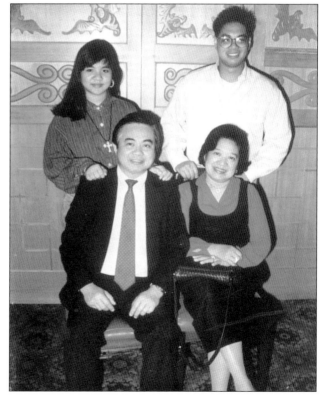

**PIONEERS OF SEABROOK.**
Alfredo and Teresita
Bartolome came to Houston
in 1969 from the Isabela
Province in the Philippines.
Teresita worked at the
Houston Methodist Hospital
as a nursing exchange student.
Alfredo worked jobs as an
orderly and an oil company
office manager. They moved to
Seabrook in 1978 and opened
a restaurant, seafood market,
and home health business.
They were the first Filipinos
to live in Seabrook. (Courtesy
of the Bartolome family.)

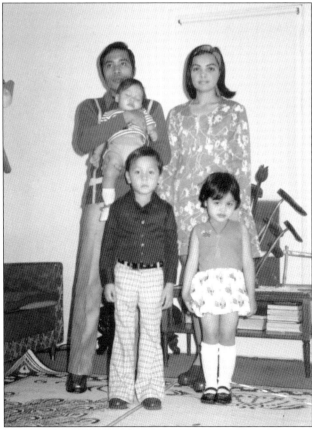

**NEW ARRIVALS.** Many
Filipino families started off in
California, Washington, or
New Jersey—states with more
liberal immigration laws—before
settling in Houston's cheaper
housing market. Pictured in
November 1973 upon their
arrival to Gardena, California,
from Manila, Philippines,
are, from left to right, (first
row) Willie and Willette
Guinhawa; (second row)
Florencio, Ricardo (held), and
Elizabeth Guinhawa. (Courtesy
of Florencio Guinhawa.)

23

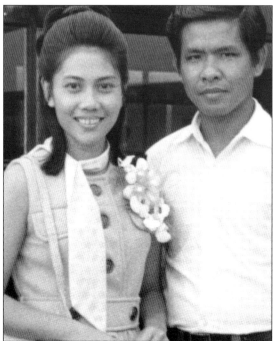

**NEWLY HIRED.** Many women came to Houston from the Philippines to pursue careers as registered nurses. In 1972, Violeta came to the United States to accept a job at the Methodist Hospital. Later, Rolando Panis followed. They soon married and built a life together. (Courtesy of Violeta Panis.)

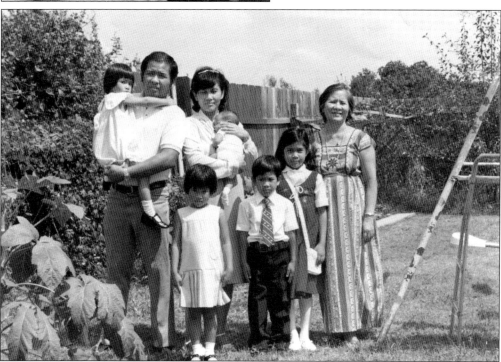

**FAMILY PORTRAIT.** Suburbs in Missouri City expanded to the greater Houston area, offering more affordable housing. As the city grew, families grew. Rolando and Violeta are pictured with their five children. Often, grandparents were flown in to help to offset the cost of day care. The family is pictured in their backyard garden, where Ilocano vegetables, not found in supermarkets at the time, were grown. (Courtesy of Violeta Panis.)

LOOKING TOWARD AMERICA. Elated for the long-awaited trip to America, Manny Compas smiles with his wife, Louella, and his two young children on March 31, 1970. After a quick approval for his green card, Manny took the opportunity of a lifetime to move his family to America and work in Houston as a certified public accountant. (Courtesy of Louella Compas.)

HERMANN PARK. In the heart of the Houston Museum District, the park is used by visitors who enjoy the scenery and gather for time together. The Compas family was one of the first families to settle in Houston. Pictured in October 1971, are, from left to right, (first row) Miriam Compas, Arnell Compas, and Manny Compas; (second row) Carmen de los Santos, Louella Compas, Nora Villamayor, Lieszl Compas, and Rose Guevara. (Courtesy of Louella Compas.)

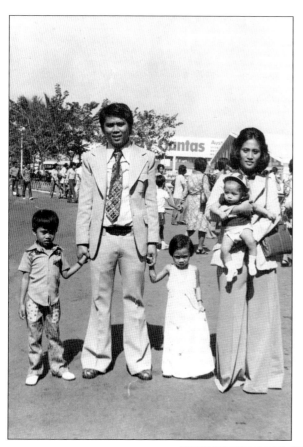

**COMING TO AMERICA, 1975.** Estanislao and Evangeline Suerte stand at Manila Airport prior to coming to the United States. Alongside them, from left to right, are children Raymond, Marites, and Estanislao Jr. During the energy crisis of the 1970s and prior to deregulation, airline prices were high. To commemorate the importance of this moment, the Suerte family dressed their best, ready to embark. (Courtesy of Elaine Suerte.)

**ORIGIN STORY.** Estanislao Suerte graduated from Far Eastern Air Transport Incorporated (FEATI) during the 1970s. Suerte came to Houston to work as an engineer. He worked for the Astrodome for 20 years. In the 1980s, Suerte also started his own real estate company, Intercon Realty, which sold homes to many Filipinos migrating to Texas. (Courtesy of Elaine Suerte.)

**COUNTRY LIVING.** The Suerte family is pictured enjoying quality time at the Bar X Ranch in Angleton, Texas, 45 minutes from their home in Quail Valley, Missouri City. From left to right are Estanislao, daughter Imelda, wife, Evangeline, sons Raymond and Jay, daughter Marites, nephew Richard Yabut, and daughter Elaine. (Courtesy of Elaine Suerte.)

**FINDING A HOME IN TEXAS.** The Echiverri family came to Houston from Chicago to escape the winter weather. In 1979, Eddie Echiverri put in for a transfer with his employer, Greyhound Lines, Inc. Echiverri is pictured with his wife, Lettie, and their seven children in their first home in Alief (Southwest Houston). (Courtesy of Dolly Echiverri Alexander.)

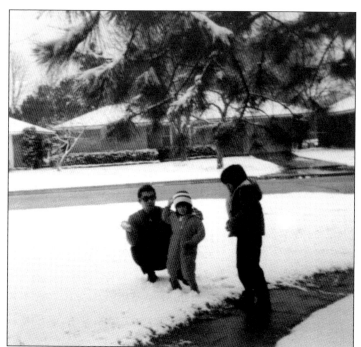

**SNOW DAY.** Roland Pamiliar immigrated to Houston in 1963 for employment and to start a new life. Pictured are his sons Ronald and Rhollie playing in the snow. They were some of the first Filipino children born in Houston. This was the first time they had ever seen snow. (Courtesy of Rhollie Pamiliar.)

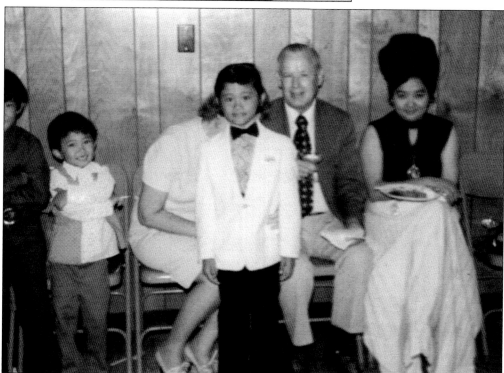

**HAIRSTYLE, 1972.** The Pamiliar brothers, Ronald and Rhollie (in the tuxedo), celebrate the wedding of their uncle Chris Pamiliar. The wedding took place at the Sacred Heart Co-Cathedral. Juliet Pamilar, their mother, sports a beehive hairdo that was popular at the time. (Courtesy of Rhollie Pamiliar.)

**DUMLAO FAMILY, 1976.** The Dumlao family attended church and schooled their children at St. Vincent de Paul. This photograph shows the family after the eighth-grade graduation of Embong and Issa Dumlao. Pictured from left to right are (first row) Bong and Wee-Wow; (second row) Carina, Issa, Embong, and Lourdes; (third row) Saturnino, Camilo, and Titan. (Courtesy of Issa Dumlao.)

**PROUD FATHER.** George Chapman Sr. came to the United States in 1971 as a dual citizen holding both a US and a Philippine passport. Both he and his wife, Betty, worked for the University of Houston—as a building engineer and accountant. The family lived in the university area. He is pictured here with his sons. From left to right are Alex, Lester, George Sr., Dean, and George Jr. (Courtesy of Marivic Echiverri Chapman.)

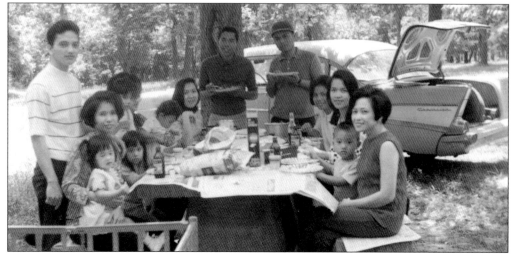

**TRUNK PARTY.** In 1964, the Houston Arboretum and Nature Center was developed, making the Houston Memorial Park a welcoming place for Filipino families to picnic. The ratio of men to women was highly imbalanced due to the influx of Filipino nurses in the late 1960s. The 1990 census still reflected the disparity: 72 Filipino men to 100 Filipino women. (Courtesy of Anthony Guevara.)

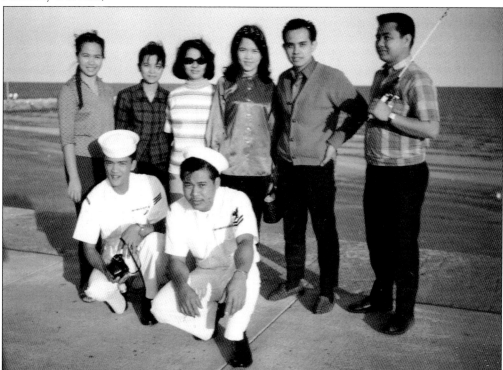

**FILIPINO SAILORS.** Edith Ronquillo Carino, unidentified, Celia Alibastro, Rose De Los Santos Guevara, Frank Guevara and Romy Ronquillo take a moment to pose with unidentified sailors on the Galveston Seawall in the late 1960s. Taking a day trip on the weekend to go fishing on the jetties, swimming, and camping out on the beach near the seawall were popular activities for many Filipinos. (Courtesy of the Guevara family.)

**LADIES IN COATS.** From left to right, Anita Orquia, Lucia Fernandez, Rose De Los Santos Guevara, Carmen De Los Santos, and Meng Orquia wear stylish coats and hairdos during winter in Houston in the late 1960s. Children May Orquia and Jojo Orquia were some of the first children born to the Filipino community in the mid-1960s. (Courtesy of the Guevara family.)

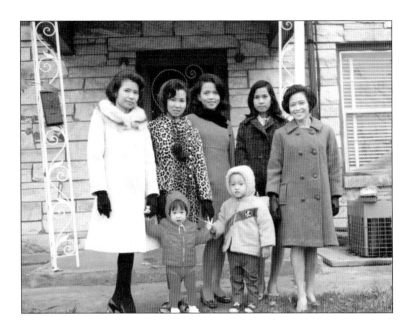

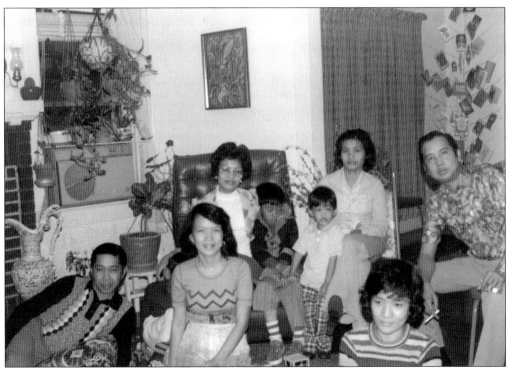

**HOUSE PARTY.** Pictured from left to right are Doming Perdido, Rose Guevara, Melva Perdido with children Larry and David Perdido, unidentified, Mila Patenia, and Bert Patenia. Friends gathered together at the Guevara house near downtown Houston. Since there were few Filipinos in Houston in the late 1960s, the whole community would attend a party to celebrate a special occasion. (Courtesy of the Guevara family.)

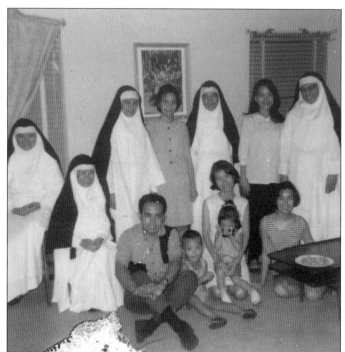

**VISITING NUNS.** Catholic nuns were welcomed to homes for fellowship, food, festivities, and Philippine hospitality. Standing with the unidentified sisters (from left to right) are unidentified and Rose De Los Santos, while Frank Guevara, May Orquia, children Jojo and Anita, and Luchie Fernandez are seated. Many Filipinos immigrating to Houston in the 1960s practiced the Catholic faith. (Courtesy of the Guevara family.)

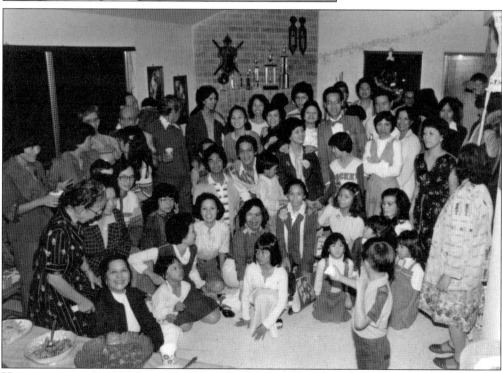

**HOUSEWARMING.** In 1980, Manny and Louella Compas filled their new home in Alief with three generations: the Compas, Burgos, Villamayor, and Valdivia families. Close friends were also present. Compas siblings traveled from as far as New York for the special event. (Courtesy of Lieszl Compas.)

**IGNACIO SIBLINGS.**
Engineer Clemente G.
Ignacio and his wife,
Emeteria, dreamt of
bringing their children
to the United States for a
better life and future. In
early 1970s, the Ignacio
family emigrated from
the Philippines to Texas
and finally settled in a
community called Alief,
whose motto is "The
Friendliest, Most Diverse
Community in Houston."
Pictured are, from left to
right, the Ignacio siblings
Victor, Rene, Marlon
and Gilda. (Courtesy
of Gilda Dimayuga.)

**IGNACIO FAMILY PORTRAIT.** Clemente G. Ignacio, mechanical engineer for Brown & Root, and Emeteria, a former teacher who worked as a food service worker for Ollie Middle School, were proud to have raised their children in Alief, Houston, known for its diverse population and excellent schools. Sons Victor, Rene, and Marlon graduated from Alief Hastings High School, and daughter Gilda graduated from Alief Elsik in 1986. (Courtesy of Gilda Dimayuga.)

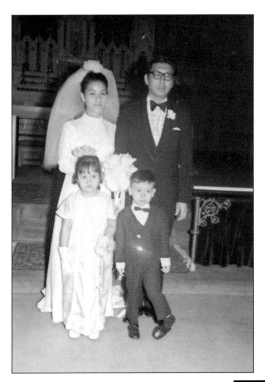

**A Successful Union.** On January 1970, Joanna Malata Villarena married Antonio Romeo T. Po at the Sacred Heart Co-Cathedral in downtown Houston. Monica Garcia was a flower girl and Floyd K. Cowart was the ring bearer. The couple met through Vickie Liu and Rosario Tamayo. Po was a Filipino Chinese who worked as an electrical engineer at companies such as General Electric, Dow, and Bechtel. (Courtesy of Joanna Po.)

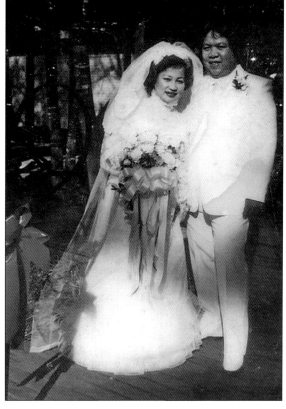

**The Love Connection.** Armando Labay Catalla and Paquita Tomilloso Carijutan connected in Los Angeles, California. After two months of courting, they married on December 31, 1983, in Prince of Peace Catholic Church, Houston, and had their wedding reception in the Holiday Inn Southwest, a hotel popularly patronized by Filipinos. (Courtesy of Pat Lindsay Carijutan Catalla.)

**Two Worlds Unite.** Glory and Doug Bombard married in the early 1980s in Notre Dame Catholic Church, a mostly Filipino congregation in Southwest Houston. The Burgos family is pictured: from left to right, Tess, Alex holding Cristine, Tim, Eileen, Cionnie, Celo, Glory, Doug Bombard, Belen, Nelson, Ludy, Connie, and Nell. (Courtesy of Issa Dumlao.)

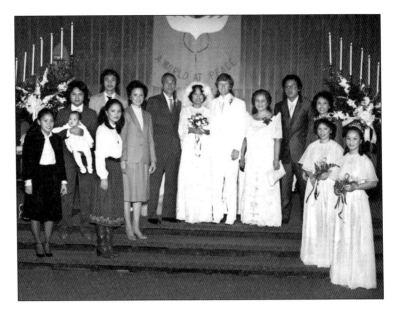

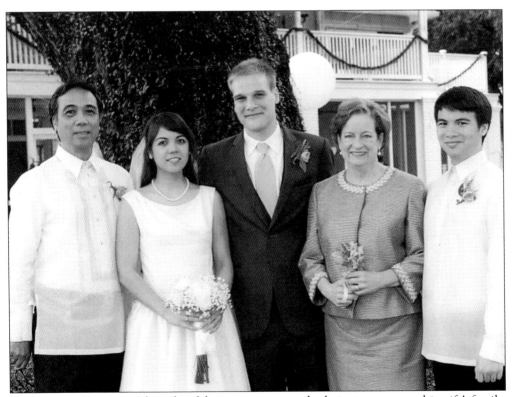

**Connecting Families.** After a fruitful overseas career and a desire to move near his wife's family, Manolo DePerio and his family moved to Houston in January 1991. Pictured at his daughter's wedding in 2013 are, from left to right, Manolo DePerio, daughter Sarah Elizabeth, son-in-law Swift Sparks, Manolo's wife, Katherine, and son Julian Rizal. (Courtesy of Manolo DePerio.)

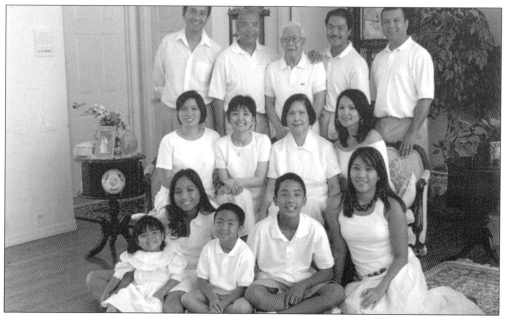

**MAKING HOUSTON HOME.** Dr. Eugenio Alcarazen was doing his residency in rehab at the Baylor College of Medicine. On June 6, 2005, the family gathered for a family reunion. Pictured are Dr. Alcarazen, Angelito Broas, Ambrocio Broas, Edmundo Broas, Danilo Broas, Edna Broas, Minerva Broas, Belen Broas, Corazon Alcazaran, Erin Broas, Gabriel Alcazaran, Joshua Broas, Daniel Broas, and Kristine Alcazaran. (Courtesy of the Broas and Alcazaran families.)

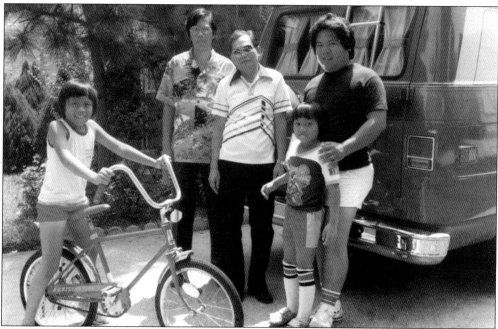

**BOYS AND BIKES.** Texas in the 1980s' heat called for short shorts and riding bikes around the Northside Houston neighborhood in the summer. From left to right are Christian Navarrete, Roger Navarrete, Pascual Carijutan, Armando Catalla, and Jason Navarrete. (Courtesy of Estrelle Carijutan Navarrete.)

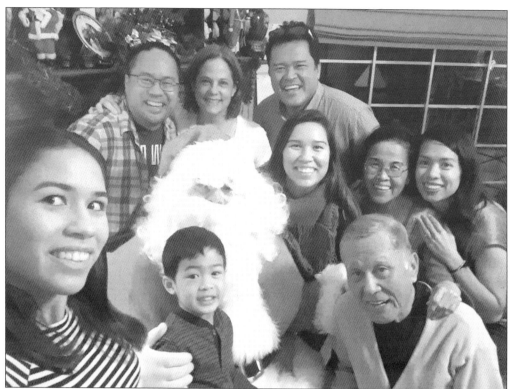

**THE BURDEOS FAMILY.** Ray Burdeos met Rosalina Cura in New York. Burdeos and Cura married on April 4, 1964, in Toronto, Canada, where she worked as a nurse. After a 23-year circuitous path, Burdeos retired to Galveston, Texas, where he pursued a bachelor of science degree in health sciences, later working in the field. His wife worked at University of Texas Medical Branch–Galveston. (Courtesy of Ray Burdeos.)

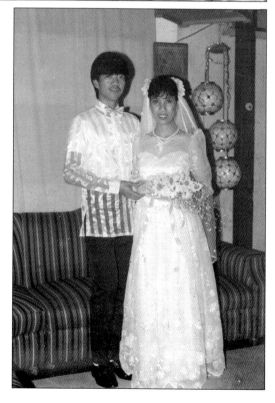

**SORIANO WEDDING.** On June 8, 1986, Bong and Shei Soriano married. They are pictured in Shei's house prior to going to the church to recite their wedding vows. Shei was a nurse in the Philippines and later came to Houston for employment. The couple settled in North Houston, where they raised their three children. (Courtesy of the Soriano family.)

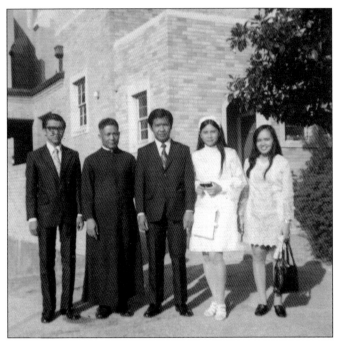

**WISH YOU WERE HERE.** In August 1972, Rolando and Violeta Sison married at Sacred Heart Church in downtown Houston. Father Leocadio Ramos conducted the wedding and Rudofo and Verma Tadeo were principal sponsors, or godparents. Verma and Violeta met as part of a group of nurses that came to work in Houston. The Tadeo and Panis families were neighbors in the Hiram Clarke area. (Courtesy of Rolando Panis.)

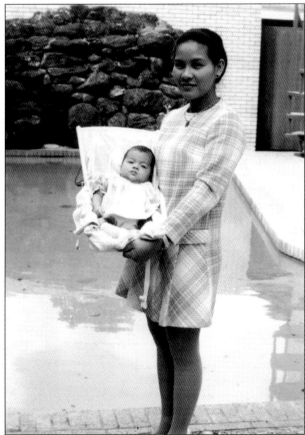

**NEW MOM.** Posing in an iconic 1970s outfit, Joanna Po stands in front of her apartment complex's pool, with her first child in her arms. Many nurses working in the Texas Medical Center found affordable accommodations in the surrounding area, allowing for quick commutes and convenient lifestyles. (Courtesy of Joanna Po.)

## *Four*

# CARING FOR HOUSTON

## ESTABLISHING A MEDICAL COMMUNITY

**BUSINESS OF NURSING.** The number of foreign-trained nurses working in Texas increased from 60 in 1970 to 1,752 in 1973 according to the *Empire of Care* by Catherine Ceniza Choy. Here, nurses pose in front of Methodist Hospital downtown in 1969. Donning signature white uniforms and caps of the era, these women forged communities in a new and foreign land. (Courtesy of Joanna Po.)

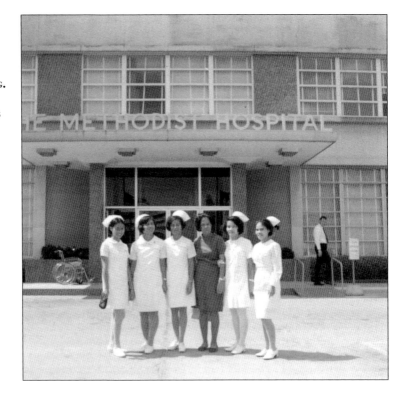

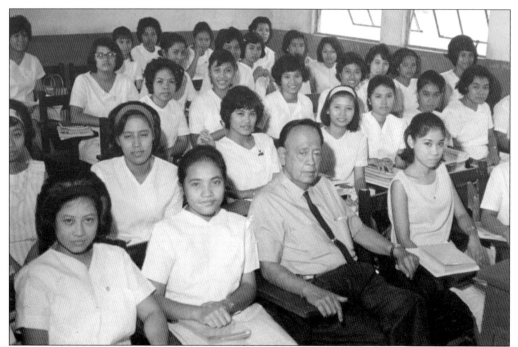

**PASSING THE BOARDS.** The State Board Poole Examination (SBTPE) was a test administered to foreign nurses. In 1977, the exam was mandatory to practice nursing in the United States. Many struggled to pass "the boards" because of the psychology section. Violeta Sison Panis said that psychology in the United States is different from how it was taught in the Philippines. According to *Empire of Care*, although it was required to pass the SBTPE to practice nursing, the Texas Medical Association wrote in an exclusion clause that bypassed the requirement. A nurse could continue to practice nursing until passing the SBTPE if she (or he) worked "under control or supervision or at the instruction of" a physician. Pictured are some future Texans, nursing students training at the Chinese General Hospital in the Philippines in 1971. (Both, courtesy of Violeta Panis.)

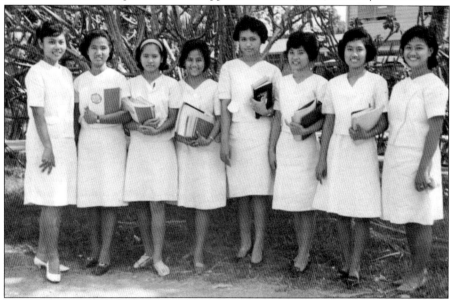

**THE PATH TO TEXAS.** Violeta Panis was born in Agoo, La Union. Her career in nursing started at Manila Central University, where she completed one year in pre-nursing and a summer in Dagupan. She attended Chinese General Hospital and graduated as a registered nurse in 1968. She was recruited to the Methodist Hospital under the Exchange Visitor Program and came to Houston in 1971. (Courtesy of Violeta Panis.)

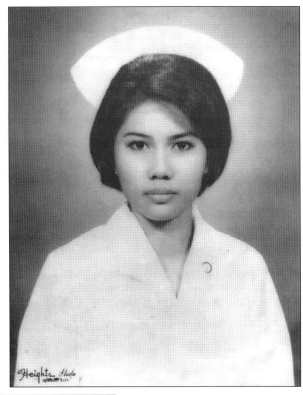

**BACKED BY GENERATIONS.** Pictured with her grandparents and parents after graduating from nursing school, Violeta Sison Panis worked an additional three years to fulfill the work experience required before coming to work in the United States. She remembers a travel agency run by Lourdes Dumlao, who later recruited her along with a group of 20 other nurses to work in the Texas Medical Center. (Courtesy of Violeta Panis.)

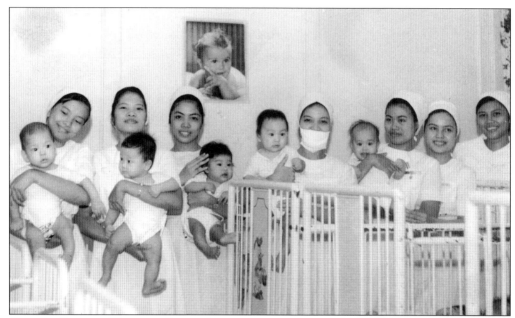

**CHINESE GENERAL HOSPITAL.** Pictured are nurses training in infant care at the Chinese General Hospital in the 1960s. Many nurses who trained at the hospital went to work at the Texas Medical Center. The Board of Nurse Examiners in Texas granted temporary work permits to nurses until they passed the State Board Test Pool Examination. (Courtesy of Violeta Panis.)

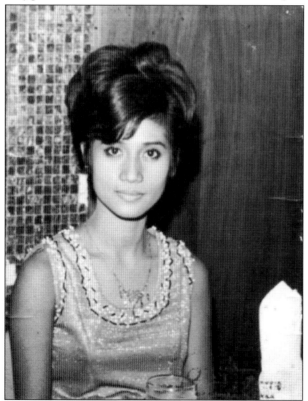

**A HISTORIC EDUCATION.** Evangeline Suerte was employed by the Methodist Hospital in Houston. She went to school at Mary Chiles College of Nursing, established in 1911 in Manila, Philippines, to cater to victims of a bubonic plague outbreak. Chiles, whom the school is named after, was an American who was sympathetic to the cause and donated to the expansion of the college. (Courtesy of the Suerte family.)

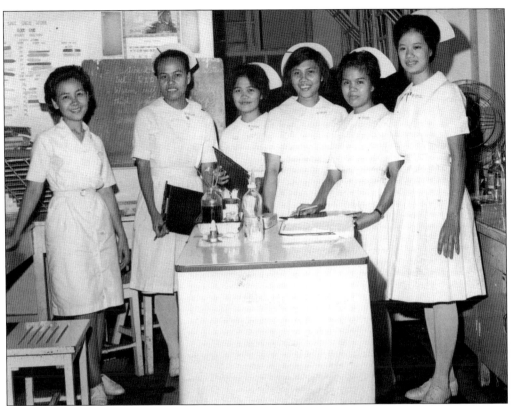

**EXCHANGE VISITOR PROGRAM.** Filipino nurses came under the Exchange Visitor Program. According to an article titled "Filipino-American Community in Houston," written by *Manila Headline* editor Jimmy Viray, the first batch of nursing graduates came to Houston in 1962. The initial monthly stipend was $300 and $120 net pay after taxes. Many requested loans from a Filipina by the name of "Mama Lazo" who helped them in their financial need. Nursing graduates in the 1960s made it to the United States, but were required to return to the Philippines as a part of the Exchange Visitor Program. Many were able to stay in Houston if their husbands or boyfriends acquired proper documentation or immigration status. (Both, courtesy of Violeta Panis.)

**EDUCATION IN HIGH NUMBERS.** When Filipino nurses came to Houston, they had a few years of experience working in a hospital in the Philippines. In the early 1970s, many Filipino nurses chose an accelerated path to work as registered nurses in the United States and sent money back to families in the Philippines. Travel agencies recruited the nurses and sent them in groups of about 20 or so batches from different hospitals and provinces. These classes of nurses became part of what would later form the backbone of the Filipino American community of Houston. According to the 2013 Rice University Kinder Institute's *Houston Asian Survey: Diversity and Transformation Among Asians in Houston*, 50 percent of Filipinos held a bachelor's degree, mostly Filipino nurses. Filipinos hold the highest number of bachelor's degrees amongst the Asian groups surveyed. (Both, courtesy of Violeta Panis.)

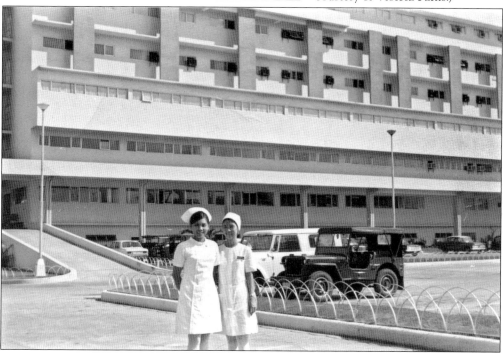

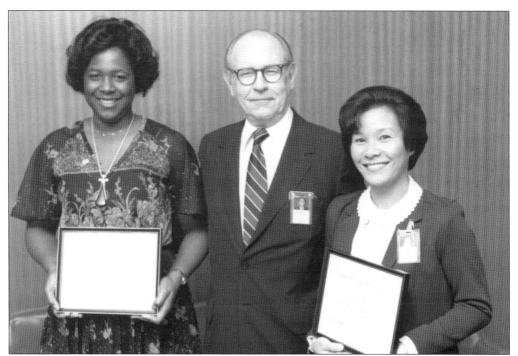

**EMPLOYEE OF THE MONTH.** A strong work ethic characterizes many Filipinos in their respective fields, and Joanna Po is no exception. Posing next to the president of Methodist Hospital in 1982, she and a distinguished colleague stand proudly holding their plaques. Pictured are, from left to right, Virginia Alexis, Ted Bowen, and Po. (Courtesy of Joanna Po.)

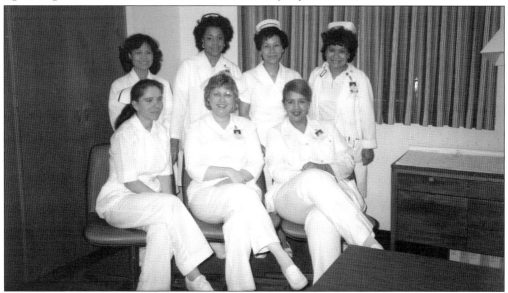

**TEAM RADIOLOGY, 1978.** Joanna Po is beloved by her staff; even today, current MD Anderson Hospital staff benefit from her counselor-like listening skills as she still keeps her door open to such matters. Her slogan is "Never be a stranger!" Pictured from left to right are (first row) Ruth Buls, Valerie Rioux, and Silvia Robertson; (second row) May Beck, Dorothy Stallworth, Joanna Po, and Myrla Abayani. (Courtesy of Joanna Po.)

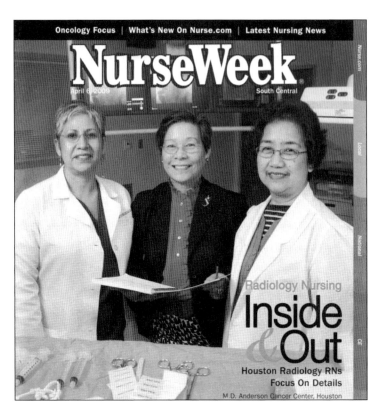

**COVER GIRL.** Joanna Po (center), Anna McGavin and Belinda Ona are featured in the April 2009 *NurseWeek* cover story about Houston's MD Anderson Cancer Center radiology department and their strides in patient care. Po was head of the department and oversaw a team, seeing more than 2,000 patients per day. Po cofounded the Association for Radiological Nursing and wrote the first radiology resource manual. (Courtesy of Joanna Po, *NurseWeek*.)

**SISTER SISTER, 1971.** Sister Zenaida Compas came to Galveston during the mid-1960s as a nurse and later became a nun. She is pictured with siblings (from left to right) Nestor, Manny, and Lolit, holding Miriam, John, Arnell, and Pam, respectively, and (standing) Lieszl. Lolit Compas worked as a nurse in New York City, where she later became president of the Philippine Nurses Association of America. (Courtesy of Louella Compas.)

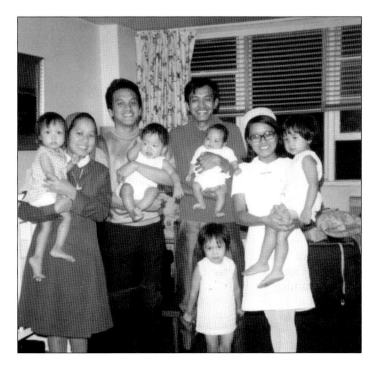

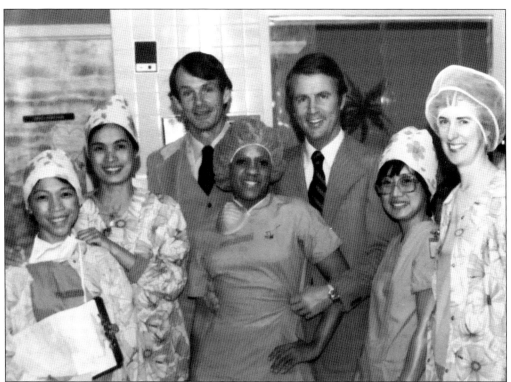

**SURGICAL TEAM.** From left to right are Zenaida Cowart, Mildred Concepcion, Mildred Gates, Lourdes Palos, and Betty Oliver pictured with doctors ? Gill and ? Stewart at Diagnostic Center Hospital (later acquired by the Methodist Hospital) in the 1970s. Blowing off some steam after a long day of work, Cowart and Concepcion were part of the first batches of nurses who immigrated to Houston in the 1960s. (Courtesy of Anne Cowart Favoriti.)

**CAPPING CEREMONY.** Shei Soriano was photographed after the capping ceremony at the University of Pangasinan in 1981. A "capping ceremony" signified the second-year achievement in nursing school. Stripes on the caps signified completed levels of training. Caps were also a trademark of nurses in training who were allowed in the hospital for on-the-job training, an unpaid internship. (Courtesy of the Soriano family.)

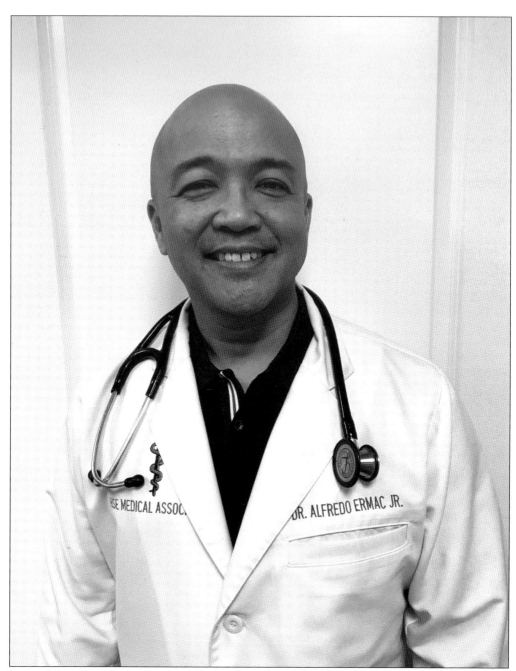

**FAMILY MEDICINE SPECIALTY.** Dr. Alfredo Ermac Jr. is a family medicine specialist in Cypress, a city north of Houston. Born in Davao City, Alfredo and family moved to Chicago, Illinois, when he was two years old. Originally arriving in Houston during the 1980s, he settled in Alief. For his bachelor's degree, Alfredo went to University of Houston and joined the Filipino Student Association. He then graduated from the University of Texas Medical Branch at Galveston in 1996, completing his residency at St. Joseph Medical Center. Alfredo specialized in family medicine to establish long-running relationships with his patients. (Courtesy of Alfredo Ermac.)

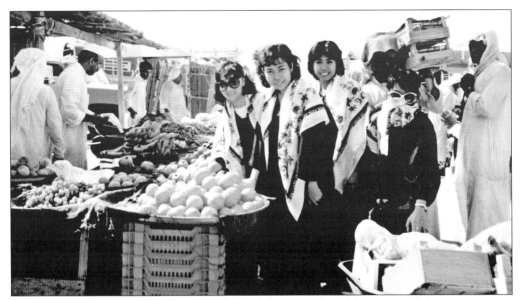

**A Taste of the Middle East, 1988.** The path between the Philippines and America was not always a straight line for many nurses. Many had brief stints in Saudi Arabia, where they were immersed in the culture, sights, sounds, and food. Pictured is a trio of newly arrived nurses sporting traditional garb in the street market. (Courtesy of Luzviminda Maravilla.)

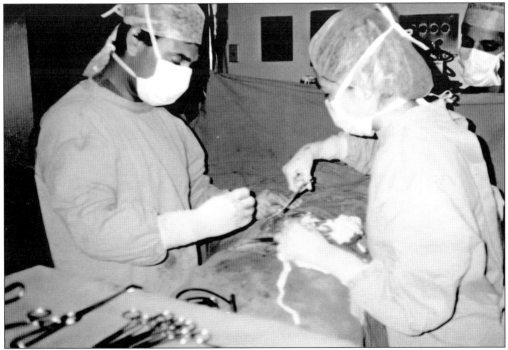

**Nip, Tuck, 1988.** Procedures can take up an entire shift, leaving staff standing on their feet for hours and missing out on lunch breaks. This is the nitty-gritty of nursing—getting hands dirty and assisting physicians in complex procedures. Nurses were recruited to Houston after acquiring international experience. Pictured is a Saudi Arabian operating room. (Courtesy of Luzviminda Maravilla.)

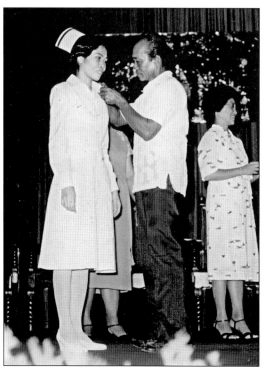

**PINNING CEREMONY.** A tearful, heartfelt moment is captured on camera: Ireno De Las Alas fastens a pin on his daughter Luzviminda Maravilla's collar upon her graduation from the nursing program at Far Eastern University in April 1981. Nurses received pins as well as ceremonial lanterns as symbols of Florence Nightingale, a historical figure who helped shape the profession. (Courtesy of Luzviminda Maravilla.)

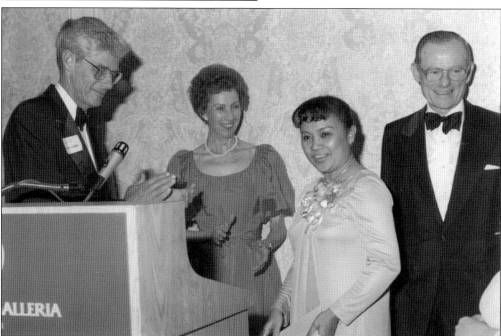

**EXCELLENCE AWARD IN CLINICAL NURSING.** In May 1982, at the Westin Galleria Houston, Eufemia Chua was the first Filipino to receive the Excellence Award in Clinical Nursing from the Brown Foundation. Pictured are, from left to right, the second MD Anderson president, Dr. Charles Lemaister; director of the Brown Foundation Catherine Doubleman; Chua; and University of Texas board of trustees member Ben Rogers. (Courtesy of Eufemia Chua.)

## Five

# THE PROFESSIONAL WAVE
## CULTIVATING CAREERS

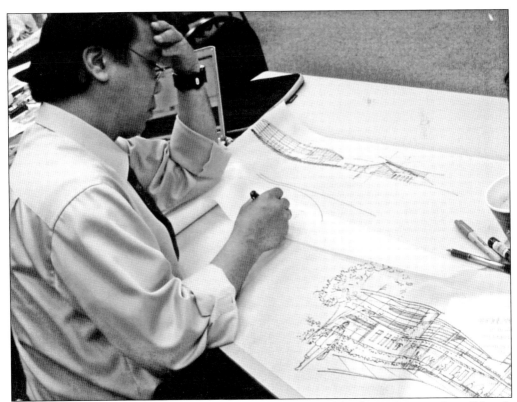

**DESIGNING THE FUTURE.** Architect Manolo DePerio is one of the few architects who still hand-sketches his work. Here, he is pictured sketching the design concept for a high school in Pflugerville, Texas, during a charrette (intense design session) in the summer of 2010, brainstorming the best ideas for the building. (Courtesy of Manolo DePerio.)

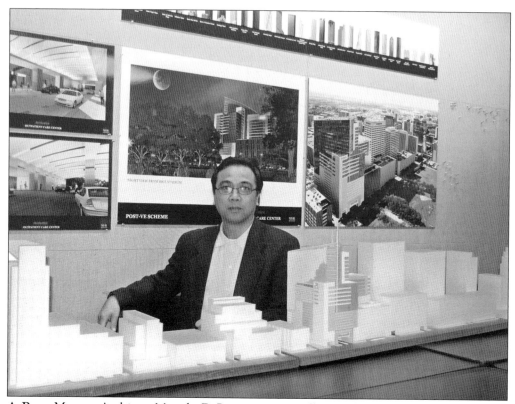

**A ROLE MODEL.** Architect Manolo DePerio poses proudly at a downtown Houston office in August 2009 with the scale model of the Methodist Hospital Outpatient Center he designed. Construction on the project started in 2007 and was finished in 2010. DePerio is one of the few Filipino architectural designers in Houston who had a hand in the design of several iconic buildings in the area. (Courtesy of Manolo DePerio.)

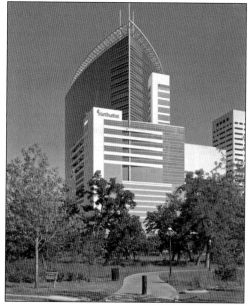

**SPIRITUAL BY DESIGN.** The building pictured was designed by DePerio with the task of reflecting the Methodist Health System core values, which are historic commitments to Christian concepts of life and learning: Servant Heart, Hospitality, Innovation, Noble Enthusiasm, and Skill. A religious design was important to the board to emphasize the spirituality of the hospital. DePerio's design was chosen over those of a number of other designers. (Courtesy of Manolo DePerio.)

**Busy at Work.** After three straight years of blistering cold and blizzardy winters in Chicago, Eddie Echiverri transferred to the Houston Greyhound Bus Lines station in 1979. He is pictured in front of a bus at the downtown Houston terminal in 1981 enjoying the warm climate of his new hometown. (Courtesy of Lettie Echiverri.)

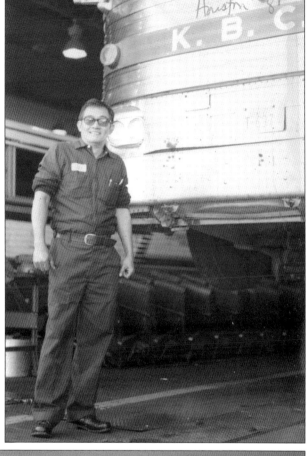

**INS Officer.** Lettie Echiverri worked as an officer at the Immigration and Naturalization Service office in Houston. She is pictured in front of the building in 1986, the year the Immigration Reform and Control Act became law. Echiverri legalized the first and last applicants for the amnesty program in 1992. (Courtesy of Lettie Echiverri.)

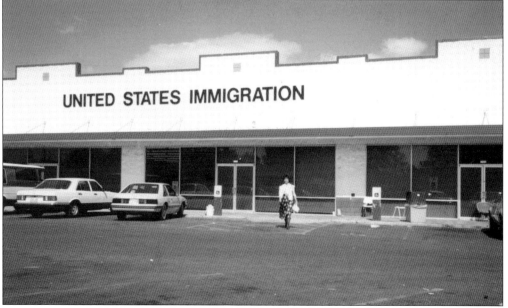

**COMMUNICATION IS KEY.** After realizing her love for medicine, combined with her love for educating others on how to regain communication, cognition, or swallowing skills after a stroke or brain injury, Gilda Dimayuga became the first Filipino speech pathologist in Houston in 1997. She obtained her master's degree at Lamar University, Beaumont. She is pictured here with her first boss at Richmond State Supported Living Center. (Courtesy of Gilda Dimayuga.)

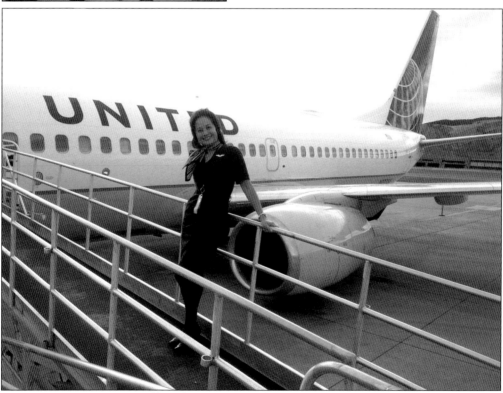

**FLY THE FRIENDLY SKIES.** Dolly Echiverri Alexander started her career as a flight attendant at Continental Airlines in July 2012. Alexander received the Service Award in her graduating class of 1,220 new recruits. Soon after, the airline was bought out by United Airlines. Alexander was based out of Houston and Denver until she resigned in September 2015. (Courtesy of Dolly Echiverri Alexander.)

**EMPLOYEES OF RIGID GLOBAL SYSTEMS.** Rigid Global Systems employees socialize at Doss Park in 2006. Many of the Filipinos working for the company live in north Houston and also make up the Couples of Christ Catholic Community. From left to right are (first row) Edwin Balba, Rufo Reynoso, Noel Ignacio, Vicente Angeles, and Eugene Galang; (second row) Citos Reynoso, Charlie Uy, Rodel Barreda, Renato Monreal, Bebar Dimagan, and Dave David; (third row) Alfin Matias, Lito Cabio (drafting manager), Ronaldo Cubillo (estimating manager), Jun Dimaluan, Marte Lagman, Bong Soriano, Romy Ravara, Arman Danao, Carlito Dayag, and Gilbert Co. Women pictured from left to right are (first row) Evelyn Cabio, Leia Barredo, Joy Balba, Dolly Dayag, Rea Danao, and Carol Ravara; (second row) Miriam Reynoso, Joy Monreal, Lilia Lagman, Jo Ignacio, Lerry Reynoso, Zenia Uy, Myrna Matias, Shirley Soriano, Tess David, Nelly Angeles, Rose Dimaluan, and Judith Cubillo. (Both, courtesy of Edwin Balba family.)

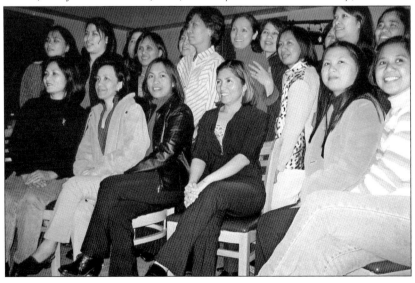

JUDGE TONI INGVERSEN. Antonia "Toni" Martinez Ilagan Ingversen was born in Manila, Philippines. Her family came to the United States in 1953 and settled in Florissant, Missouri. She moved to Texas to pursue her education. Ingversen received a doctor of jurisprudence at the University of Houston in 1973. That same year, she was admitted to practice law before the Supreme Court of the State of Texas. Ingversen ran for judge in the Fourteenth Court of Appeals in 1984, the 129th State District Court in 2002, and again for the Harris County Criminal Court at Law No. 15 in 2010. Upon the recommendation of council member Martha Wong, Mayor Bob Lanier appointed Ingversen as a full-time municipal court judge in March 1996. She was reappointed biennially until 2011, whereupon she retired as a full-time judge and was appointed as an associate judge until 2015. (Courtesy of Antonia Ingversen.)

**SKILLED ELECTRICIAN.**
Rolando Panis
worked at Stewart
and Stevenson as a
wireman, building
electric generators. The
company was bought
out by General Electric
(GE). He retired from
the GE plant in San
Jacinto after 37 years of
service. Panis learned
the trade during
college summer breaks
in the Philippines.
He came to Houston
to reconnect and
marry his girlfriend,
Violeta Sison, a nurse
in 1972. (Courtesy of
the Panis family.)

**SUERTE.** Estanislao Suerte
came to Houston in 1975 and
began work as a mechanical
engineer at the Astrodome,
where he worked for 20
years. He was a member of
the Masonic Lodge of Texas,
Solidarity Lodge No. 1457
Ancient Free and Accepted
Masons, formed mostly by
Filipino Masons, where he
once served as grand master.
(Courtesy of Estanislao Suerte.)

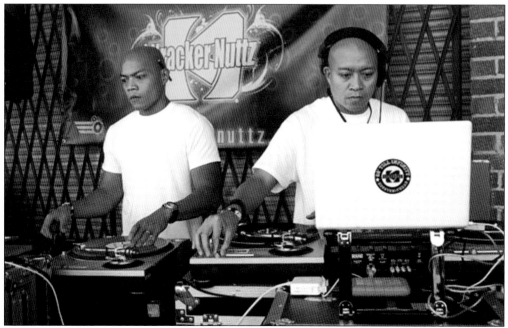

**GOING KRACKER NUTTZ.** In 1998, Jason Navarrete "DJ Baby Jae" (left), Christian Navarrete "DJ KleanCutt" (right), and manager Grace Rodriguez shared the vision of integrating culture into their music and entertainment. The Kracker Nuttz were introduced to the Houston community in 1998. DJ KleanCutt and DJ Baby Jae are pictured. In 2016, a mayoral proclamation was issued honoring Houston's Filipino American DJs. (Courtesy of Christian Navarrete.)

**MAKING SCRATCH.** The Kracker Nuttz organization grew with the addition of radio veteran Ronald Gaviola, also known as "DJ Ron EG." The trio made its way onto 97.9 the BOX. The Kracker Nuttz hit the Houston scene in full force, incorporating their turntables, tricks, and scratches into all of their radio mixes. (Photograph by Lee Reforma, courtesy of Christian Navarrete.)

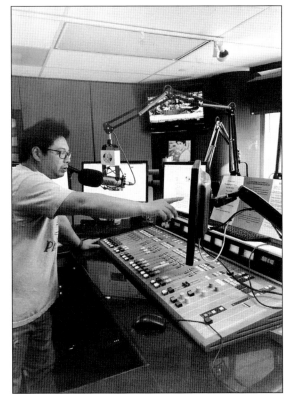

A Creative Powerhouse. Tina Hernandez Zulu (left) and her husband, Josh Zulu (holding their son, Michio), founded Zulu Creative in 2006; she is also the owner of Kimono Zulu. She is a University of Houston alumna, holding bachelors of arts degrees in marketing and entrepreneurship from the nationally top-ranked Wolff Center for Entrepreneurship. (Photograph by Julie Soefer, courtesy of Tina Zulu.)

Radio Personality. Houston's beloved production director Jerome Ronquillo is also known as "Yo-J" at Cumulus Media, radio station 104.1 KRBE. A graduate of the University of Houston, he is known for his comical and quick-witted comments and professional voice-overs, and he has written and produced numerous commercials and promos for on-air broadcasts. He is the first prominent on-air Filipino in Houston. (Courtesy of the Ronquillo family.)

**DJ Ryan E.** Ryan Echiverri has been spinning since 1986 as "DJ Ryan E." That was the year the California Bay Area saw the alliance of five DJ groups known as the "Legion of Boom." While California was making innovative strides in the DJ scene, Houston echoed the movement and Echiverri was part of it. Echiverri (left) is seen here with partner Joe Applewhite from vinylpimp. com, Swift Productions. (Courtesy of Ryan Echiverri.)

**DJ Johnny J.** John Jopio, also known as "DJ Johnny J," started spinning records at house parties when he was a teenager in the late 1980s. The "Booth Pimps" was founded by Jopio and others in 2008 to leverage the talent of other DJs. From left to right, Robin Wong "DJ Seek," Earl Awayan "DJ Ebonix," DJ Johnny J, and Jay Namoc are pictured at an event in Austin. (Courtesy of John Jopio.)

**TOP CHEF.** Paul Qui, born in Manila, Philippines, in 1980, won the ninth season of the reality television cooking competition *Top Chef* in 2011. A James Beard Award winner, Qui opened Aqui, a Montrose restaurant, in August 14, 2017. Qui is pictured with "DJ Johnny J," John Jopio. (Courtesy of John Jopio.)

**DANDEE WARHOL.** Danao took art classes growing up, but ended up graduating from the University of Houston with a bachelor's degree in finance and management. Working in finance helped fund his passion for art and fund the opening of War'Hous art gallery in 2010. Danao is pictured seated in front of his pieces at Art Basel in Miami Beach in 2015.

**Future Tribez.** Born in Makati, Manila, Philippines, Royal Sumikat moved to Houston in 1995 after living in Saudi Arabia, where her father was an Overseas Filipino Worker (OFW). Sumikat is one of the first Filipina muralists in Houston and finds inspiration through traveling, anthropology, and indigenous identities all over the world. Her mural, titled *Future Tribez,* was located at 1502 Sawyer Street in Houston. (Courtesy of Royal Sumikat.)

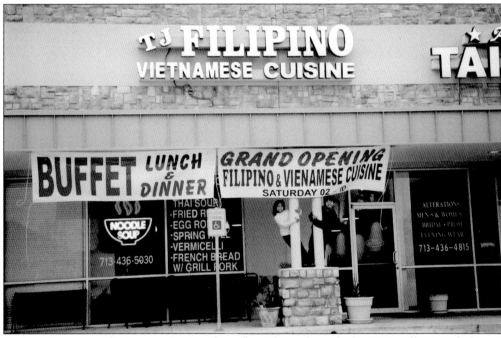

**Grand Opening.** Filipino communities kept flourishing through the 1990s, allowing the grand opening of the first Filipino buffet in Pearland, a suburb of Houston. Renamed as TJ Filipino Cuisine and operated by a pair of fathers, Antonio Dinamling and Santiago Maravilla, the establishment caters to the surrounding and increasing demand for home-style cooking. Pictured in February 2006 are the youngest of their children, Camille Dinamling (left) and Jevh Maravilla. (Courtesy of the Maravilla family.)

IN THE ACT. Proud new co-owner Santiago Maravilla is caught in the midst of finishing up a catering order. This soft opening of the restaurant in early 2006 allowed the community a taste of what was to come for TJ Filipino Cuisine. Pictured in February 2006 are, from left to right, Jevh Maravilla, Camille Dinamling, and Santiago. (Courtesy of the Maravilla family.)

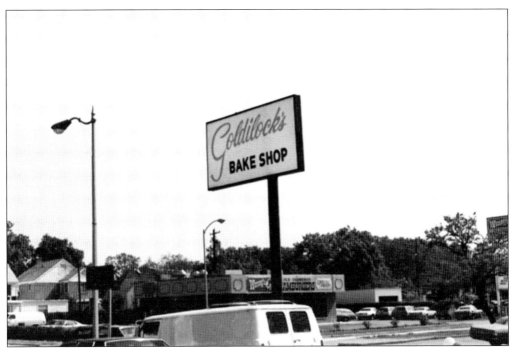

GOLDILOCK'S BAKESHOP. Houston Goldilock's was at the Holcombe Boulevard and Greenbriar Drive intersection before closing down and was headed by Maria Flor Meneses. This photograph shows the sign of its then newest branch in Houston, which opened shortly after the Los Angeles, California, location in 1976. Many Filipino nurses frequented the dessert shop for a sweet taste of home since it was near the Texas Medical Center. (Courtesy of Kokoy Gorospe Severino.)

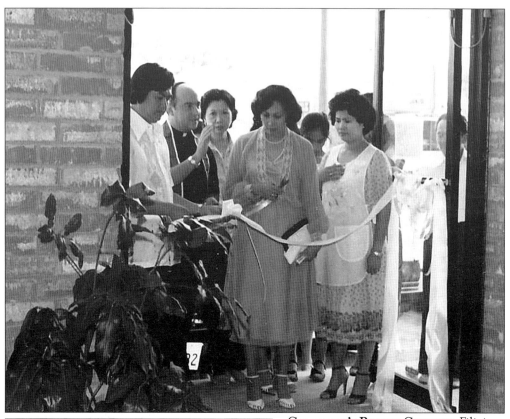

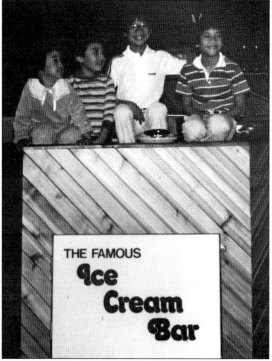

**GOLDILOCK'S RIBBON CUTTING.** Filipino Chinese sisters Milagros Leelin Yee and Clarita Leelin Go, alongside their sister-in-law, Doris Wilson Leelin, opened a chain bakeshop in Makati, Manila, Philippines during 1966. In the late 1970s, Goldilock's Bakeshop blessed and cut the ribbon of its newest location in Houston, Texas, situated close to the Texas Medical Center. (Courtesy of Kokoy Gorospe Severino.)

**THE FAMOUS ICE CREAM BAR.** The Javier family came to Houston from Dallas to open two ice-cream stores: Bresler's 33 flavors and the Famous Ice Cream Bar. The Famous Ice Cream Bar was open from 1981 to 1994 in Sharpstown Mall. Pictured are, from left to right, business partners and cousins Eileen Andres, Leo Andres, and twin brothers Ryan and Brian Javier. (Courtesy of Emily Ng.)

HAPPY ENDINGS. Ryan Javier, Texas born and raised, worked in the loan business for a while and met Emily Ng in 1994. After the Great Recession of 2008–2009, unable to find employment, they decided to buy a food truck in 2011. Javier and Ng are pictured with Mayor Sylvester Turner in 2017 at Super Bowl Live at Discovery Green in front of their truck, designed by Jim de Vega. (Courtesy of Emily Ng.)

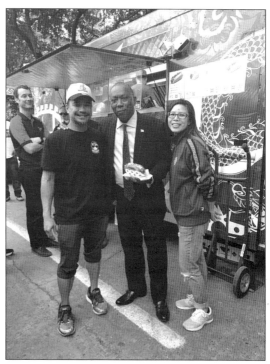

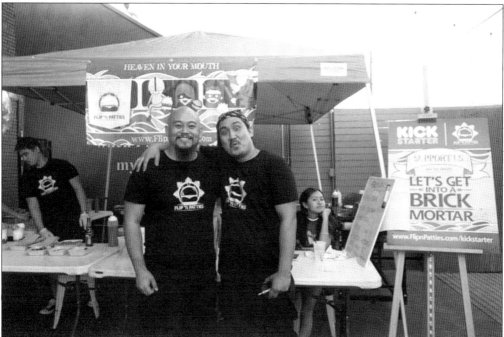

FLIP'N PATTIES. Flip'n Patties was founded by cousins Michael Jante (left) and Donramon Jante and debuted on social media in 2012. The food truck also provided Filipino street food for Lincoln Bar on Washington, another Filipino-owned establishment. Prior to opening their brick-and-mortar location, they were robbed at gunpoint. Still, they persevered and celebrated their grand opening on March 2018 at 1809 Eldridge Parkway. (Courtesy of Michael Jante.)

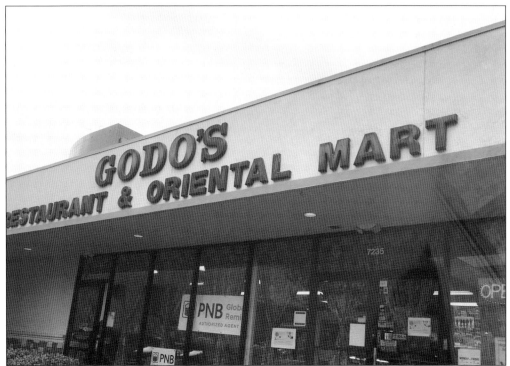

GODO'S. Located in the Texas Medical Center, Godo's Bakery and Restaurant was opened in 1997. In addition to being a Filipino eatery, the store has an online store that sells everything from phone cards to chicken adobo and siopao that can be shipped to someone's house via two-day air. The restaurant was started by Dina Javier and Adelfa Andres and named after their father Godofredo. (Courtesy of Emily Ng.)

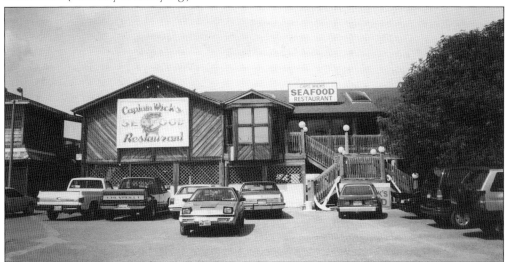

CAPTAIN WICK'S, 1978. Captain Wick's was located at 400 Waterfront Drive on the Galveston Bay, just off Highway 146 in Seabrook, Texas. The business was the first Filipino-owned restaurant in Seabrook and was operated by Alfredo and Teresita Bartolome, who opened the restaurant and seafood market in 1978. The family operation also includes Pier 8 Restaurant. (Courtesy of the Bartolome family.)

THE INFORMATION TECHNOLOGY (IT) WAVE. Groups of Filipinos started to come to Houston in 1993 for IT jobs. The group pictured worked at Software Brewers, Inc., in Makati, Philippines. Joemel Jallorina is with his wife, Merc, (to his left) and friends. They had their first car, a Toyota Tercel, blessed at St. Cyril Alexandria Catholic Church. Joemel contracted to work at Star Enterprise and later became a Shell employee. (Courtesy of Joemel Jallorina.)

INTERNET BOOM. RCG Global Services recruited Filipino IT professionals to work mostly in the oil and gas industry in Houston in the early 1990s. From left to right are (first row) Aireen Estuart, Nat Ramirez, Myrna Fernando, Laren Villasin; (second row) Rollo, Elaine, Beng Ramirez, Maricar Pierson, Maribeth Zamora, and John Abad; (third row) Roy Abuel and Jay Yuse. At the time, many lived in the Gessner and Richmond area near Chinatown. (Courtesy of Laren Villasin.)

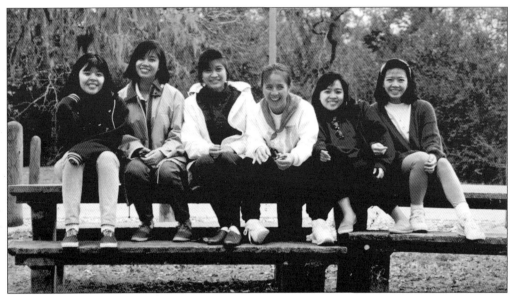

WOMEN WHO CODE. Pictured from left to right, Aireen Estuart, Elaine ?, Laren Villasin, Myrna Fernando, Natalin Ramirez, and Maricar Pierson were recruited to work at Shell Oil Company in 1993. They were experts in client server technology and website development during the start of the Internet technology boom. In some cases, short-term contracts led to long-term employment with the company. (Courtesy of Laren Villasin.)

ASIAN WOMEN EMPOWERED. In 2013, Christy Poisot spoke at Asian Women Empowered (AWE) about "Protecting Your Digital Footprint." She graduated from the University of Houston–Downtown with a bachelor's degree in business administration in computer information systems and began working at Shell Oil Company in 1997. She was elected vice-chair of the American Petroleum Institute for the Information Technology Security Subcommittee (ITSS) in 2018. (Courtesy of Christy Poisot.)

**BY THE BOOK.** Gary Ilagan, an AV-Preeminent–rated lawyer, was named 2018 Houston Immigration Law "Lawyer of the Year" by the Best Lawyers in America, elected state president of the Philippine-American Chamber of Commerce Texas (2015–2020), and graduated from Alief Hastings High School, Vanderbilt University, and Texas Tech University School of Law. The Ilagan family (Emiliano, Lolita, Gary, Mel Jr., and Brian) moved to Houston from Chicago in 1982. (Courtesy of Gary Ilagan.)

**KEEPING IT REAL AT THE CORE.** Pictured from left to right, Ella Guinhawa, Robert Chan, Caroline Perez, Julio Molina, Nelvin Adriatico, Nathan Schmidt, Sofia Martinez, Monica-Storm Olsen, Avinash Thadhani Adriatico, Theresa Gutierrez, and Tristan Perez form the Sugar Land–based Core Realty team. Adriatico started Core Realty in July 2015 and has brought together diverse-teams in real estate and community organizations. (Courtesy of Nelvin Adriatico.)

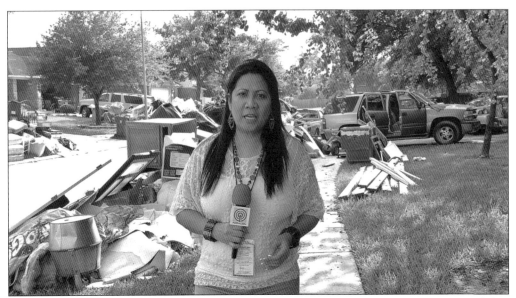

ON THE SCENE. In 1988, Cheryl Piccio-Echols visited Houston from the Philippines with her family. In 1992, she made Houston home. In 2017, she became a news anchor for Balitang America, a Philippine news station, and reported on the aftermath of Hurricane Harvey. The photograph shows Northwest Houston, within the Highland Glen subdivision, which was flooded by the levee overflow. Many Filipino residents live in the area. (Courtesy of Ron Echols.)

PIONEERS OF MEDIA. On July 30, 2016, Pinoy Houston TV (PHTV) launched *Howdy Philippines,* broadcasted on KVVV 15.3, featuring Filipinos of Houston for one hour, once a week. Pictured is the original Pinoy Houston TV cast and crew responsible for starting the first ever Filipino-owned-and-operated show in Houston. Leonides Reyes (back row, third from the left) is the owner of PHTV. Noemi Frias, managing director, is seated holding a fan. (Courtesy of Pinoy Houston TV.)

# *Six*

# PROUD TO SERVE
## FILIPINO ORGANIZATIONS

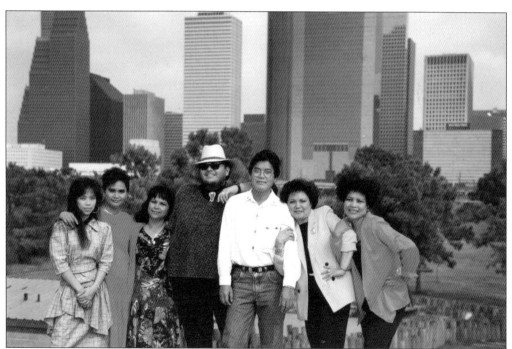

**HOUSTON'S GOT TALENT.** To gear up for a mid-1980s statewide singing contest titled *Tawag ng Tanghalan*, loosely translated "Call of the Stage," (from left to right) unidentified, Marivic Ponce, Linda Real, Jake Garcia, Toty Concepcion, Louella Compas, and Naty Castro pose for a promotional photo shoot in front of the iconic Houston skyline near downtown. (Courtesy of Louella Compas.)

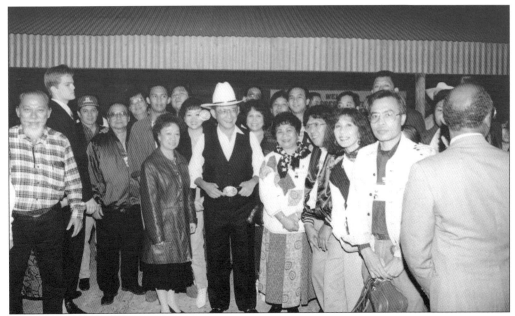

PRESIDENTIAL VISIT. Fidel V. Ramos, president of the Republic of the Philippines, was welcomed by the Filipino American Council of Southern Texas (FACOST) and all the Filipino American organizations in Texas. The welcome dinner took place on November 17, 1993, in the Grand Ballroom of the Doubletree hotel at 2001 Post Oak Boulevard in Houston. (Courtesy of Florencio Guinhawa.)

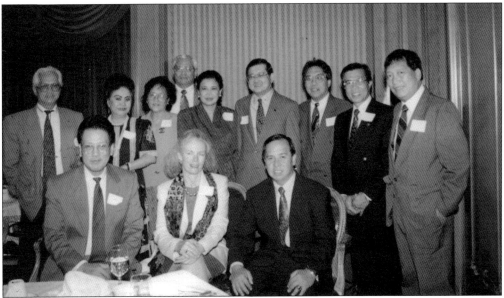

TRADE MISSION, 1993. Richard Gordon, chairman and administrator of the Subic Bay Metropolitan Authority, visited Houston to encourage investing in Subic Bay development. Pictured from left to right are (first row) Jess Medina, Nancy Ayer Hawes, and Richard Gordon; (second row) Don Piniones, Consul Marilou Langcauon, Babbie Piniones, Roberto Garcia, Consul Zenaida Tolentino-Rabago, Ed Tioseco, Gordon Quan, Pete Barsales, and Consul General Juan Saez. (Courtesy of Florencio Guinhawa.)

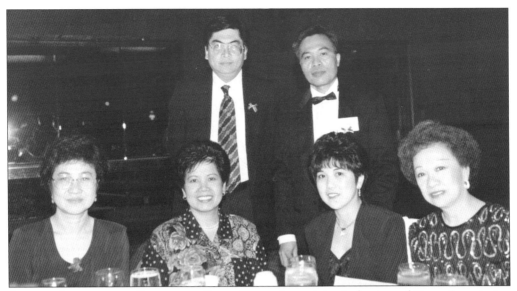

**ALUMNI ASSOCIATIONS INDUCTION BALL.** Pictured at a joint induction of Texas Association of Mapua Alumni (TAMA) and University of the Philippines Alumni Association (UPAA) Houston Chapter are members (first row) Fe Sarmiento, Marilyn Malixi, unidentified, and Maddie Crisostomo; (second row) Leo Calimbas and Florencio Guinhawa. The event took place at the JW Marriott Hotel Galleria in Houston on March 18, 1995. (Courtesy of Florencio Guinhawa.)

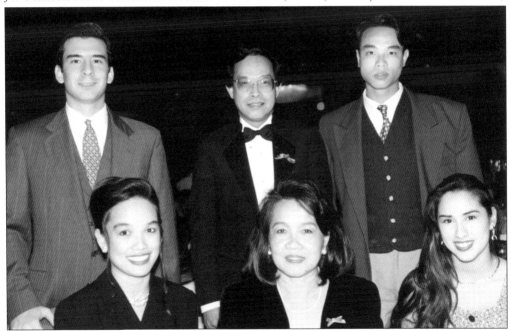

**FAMILY AFFAIR.** Josefino and Marina Beltran's family attend an officers' induction ceremony for the Texas Association of Mapua Alumni (TAMA) and University of the Philippines Alumni Association (UPAA) Houston Chapter at the JW Marriott Hotel Galleria in Houston on March 18, 1995. Pictured from left to right are (first row) Jemmina Beltran Gualy, Marina Beltran, and unidentified; (second row) Jaime Gualy, Pepito Beltran, and Jojo Beltran. (Courtesy of Florencio Guinhawa.)

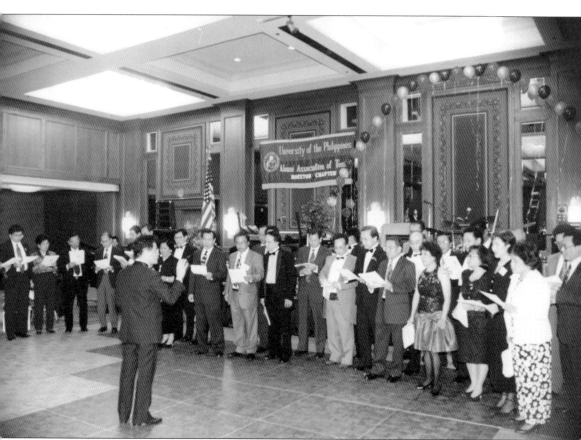

**INDUCTION OF OFFICERS.** Two active associations of the Filipino community, the Texas Association of Mapua Alumni (TAMA) and University of the Philippines Alumni Association (UPAA) Houston Chapter, held a joint induction ceremony March 18, 1995, at the JW Marriott Hotel Galleria in Houston. Traditional dances such as the *Rigodon de Honor* were performed. The president of the Mapua Institute of Technology, Manila attended as a guest speaker at one of the induction ceremonies. Filipino American immigrants organized themselves via their alma maters to continue to strengthen their relationships in the Houston community. Most of the 1967–1968 graduates immigrated in groups to Houston for jobs. Many became Houston residents and established families. (Courtesy of Florencio Guinhawa.)

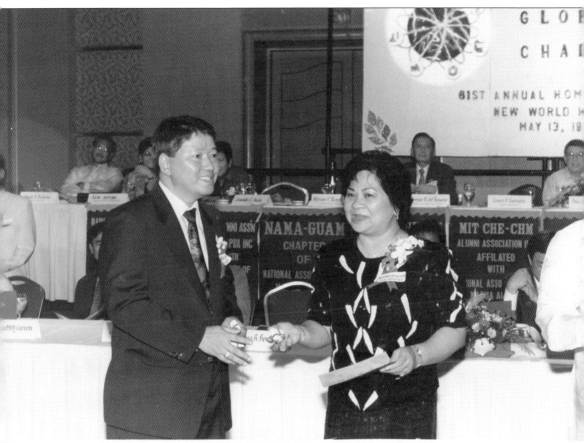

NATIONAL ASSOCIATION OF MAPUA ALUMNI
61st ANNUAL HOMECOMING AND CONVENTION
NAMA: MEETING GLOBAL CHALLENGES
NEW WORLD HOTEL                                    MAY 13, 1995

THE GODMOTHER. Norma Benzon, a longtime Houston community leader, is pictured at the National Association of MAPUA Alumni (NAMA), 61st Annual Homecoming and Convention, at the New World Hotel, Manila, Philippines, May 13, 1995. Norma was born on April 21, 1948, in Manila, Philippines. She moved to Houston, met Meredith Benzon, and was married for 35 years. Benzon obtained a bachelor of science degree in architecture from Mapua Institute of Technology in the Philippines. Norma worked for JP Morgan Chase as a vice president before retiring after 24 years of service. She served as a chief executive officer and executive director with the Young Women's Christian Association (YWCA) of Houston. Norma's life philosophy was to fully utilize her attributes in an environment where people and community are a priority. She was an outstanding civic leader and fundraiser. Benzon was a leader beloved by the Filipinos in Houston. She is the official godmother of many Filipino American children born in Houston. (Courtesy of the Benzon family.)

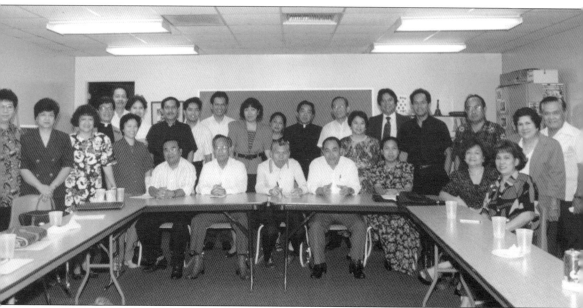

FORMATION OF THE FILIPINO MINISTRY. A meeting of religious organizations and other groups with religious activities was held on June 25, 1993, at the Holy Family Church in Missouri City, Texas. The purpose of the meeting was to coordinate with leaders of religious organizations and other groups sponsoring any religious celebrations the scheduling of the religious activities; to review the liturgy celebrations; and to establish guidelines for the activities. Examples of the topics discussed include conflicting dates, the need for a directory of religious organizations and prayer groups, need for priests' attendance, fundraising, lack of a community projects for the religious organizations, uniformity of prayers, too many Santo Niño celebrations, focus on social aspects rather than the religious aspects, and no permanent place for religious celebrations. Standing are Vicky Escueta, unidentified, Mellie Ong, Fr. Ron Aranda, unidentified, Margie Calo, unidentified, Fr. Tony Maramot, Fr. Albert Maullon, unidentified, Lina Uhali, Angelina Sarmiento, unidentified, Deacon Elie Calonge, Cindy Tengco, unidentified, Fr. Seth Hermoso, Ernie Abadejos, and two unidentified. Seated are unidentified, Syl Riel, Al Lopez, Emil Labuga, two unidentified, and Paz Abadejos. (Courtesy of Florencio Guinhawa.)

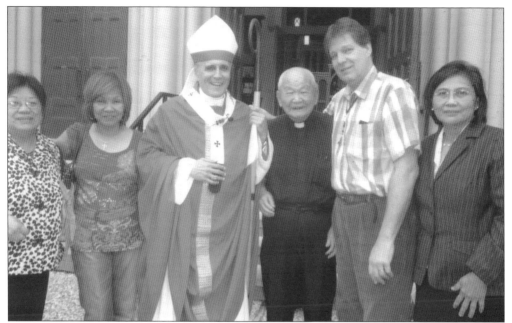

**A GROWING FAITH.** This image celebrates the 50th anniversary of the priesthood of Fr. Luis Chia on October 25, 2009, at the Co-Cathedral of the Sacred Heart in downtown Houston. Pictured from left to right are Rosie Capalad, Norma Tecson, Card. Daniel DiNardo, Fr. Luis Chia, unidentified church greeter, and Violeta Panis. The growing Catholic community was one of the reasons DiNardo was appointed as the first Texas cardinal. (Courtesy of Violeta Panis.)

**FAITH UNITES.** Senyor Santo Nino was celebrated every last two weekends of January during the 1980s. This was held at St. Laurence Catholic Church community center. Some of those pictured include Richard Bantigue, George Toralba, Al Lopez, Emil Labuga, and Gilbert Medrano, Eden Bantigue, Margie Calo (annual coordinator), and Roger Carungcong. (Courtesy of Gilda Dimayuga).

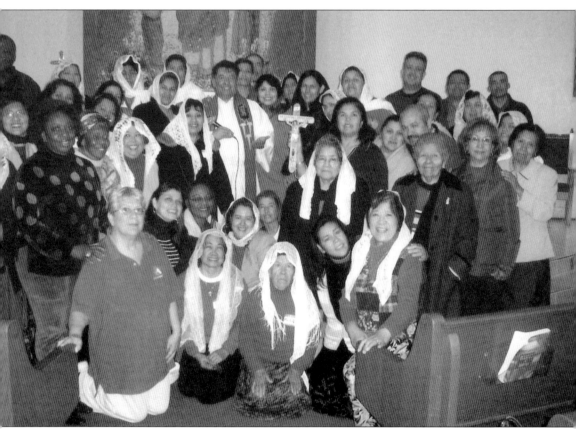

**A Spiritual Community.** Members were consecrated to a Catholic prayer group called the Devotion to the Most Precious Blood of Jesus at St. Mark Evangelist Catholic Church in Houston. Aurora Protomartir (front right) started the group in 2004. The group later combined with the Holy Rosary Crusade, a nonprofit Marian organization established in 1981. The Holy Rosary Crusade brought a statue of the Virgin Mary to homes. Families prayed the rosary for one week or longer with the theme that "the family that prays together, stays together." On October 5, 1985, the Holy Rosary Crusade received a Certificate of Recognition from then mayor Kathy Whitmire, and designated October 5 as "Holy Rosary Crusade Day." The first official Filipino Catholic newsletter, the *Crusaders*, was published. To involve the youth, members encouraged their sons to organize a basketball team. On May 14, 1986, a basketball team called the Crusaders was formed. (Courtesy of Violeta Panis.)

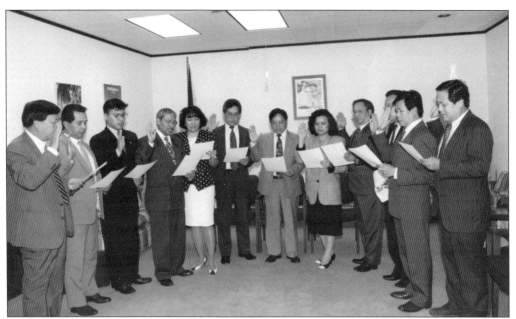

**FILIPINO AMERICAN COUNCIL OF SOUTHERN TEXAS (FACOST.)** These photographs were taken during the induction of directors in June 1993 at the Philippine Consular Office in Houston. Organizations like this one were initially created to handle the visit of Philippines presidents at the then existing consulate. However, the consulate shut down in November 1993 due to a change of leadership. Currently, they work as ambassadors to aid immigrants in various services. Above, inductees, from left to right, include Allen Tiongco, Paul Dalde, Doug Tigtig, Pete Barsales, Dr. Arsenio Martin, Tom Anuba, Pepito Beltran, Nora Peralta, Tito Refi, Consul Juan Saez, Wally Arias, Lina Umali. Below, from left to right, are (first row) Nora Peralta, Tom Anuba, Allen Tiongco, Pepito Beltran, and Dr. Arsenio Martin; (second row) Doug Tigtig, Pete Barsales, Tito Refi, Wally Arias, Lina Umali, Paul Dalde, and Consul Juan Saez. (Both, courtesy of Florencio Guinhawa.)

**ISANG MAHAL.** The first Filipino American History Month celebration in Texas was at Texas A&M University with the annual "Isang Mahal – One Love" dance showcase in October 1999. Pictured at the first "Isang Mahal" are, from left to right, founder Arnold Paguio, special guest emcee and poet Dr. Dawn Mabalon, founder and emcee Anthony Guevara, and sponsor from Texas A&M's multicultural services Lorna Hermasura. (Courtesy of Anthony Guevara.)

**GOODPHIL 2000.** After Rex Navarrete's stand-up routine, students take a moment to relax at the Texas A&M University Recreation Center. From left to right are (first row) Anthony Guevara and comedienne Bernadette Balagtas from the movie *The Debut*; (second row) Robert Guevara, unidentified, Jed Foronda, comedian Navarrete, Cyril Manuel, PJ ?, Willie Manuel, and Jonas Robinett.

**UNIVERSITY OF HOUSTON FILIPINO STUDENT ASSOCIATION (FSA), 1998.** FSA students of the University of Houston–Central Campus gather for the International Food Festival to sell various Filipino foods, such as pancit, chicken adobo, pork barbecue, puto, and lumpia shanghai. These international festivals were held annually to increase cultural awareness. The two ladies are Yvonne Maske (left) and Lani Imperial, with unidentified male students. (Courtesy of Lieszl Compas.)

**FILIPINO COUGAR PRIDE.** University of Houston–Central Campus Filipino Student Association officers and members are featured in this photograph taken in the fall of 1985 in the student center courtyard. Sitting amongst this group are future doctors, pharmacists, bankers, contract managers, and a local favorite radio DJ. (Courtesy of Lieszl Compas.)

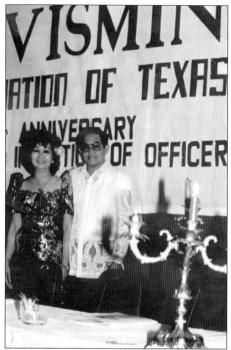

**DRESSED FOR THE BALL, 1991.** Amelita and Orlando Echiverri attend the Vismin Induction Ball at the Adam's Mark Hotel on Westchase. Echiverri was the president-elect of the Visayan-Mindinao (VISMIN) Association of Texas. The couple are wearing the traditional Filipino dress, a Maria Clara gown and barong tagalog. (Courtesy of Lettie Echiverri.)

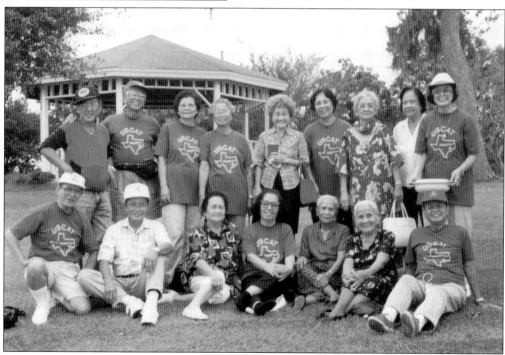

**USCAT, 1990.** The United Senior Citizens Association of Texas (USCAT) is a community group of active Filipino senior citizens whose motto is "To serve, not to be served." Fred Villamayor (front row, far left) was the founder. According to a program dated June 30, 1990, the group had 54 members. The induction of officers was conducted by the Philippine consul general Antonio Ramirez. Delfin Palaypay was president. (Courtesy of Nora Villamayor.)

**Houston Ilocanos Organize, 1978.** From left to right, Tom Amaba, Pres Aranas, and Romy Ronquillo are pictured with two unidentified entertainers. They are taking a time-out during an Ilocano Club meeting held at the Ronquillo house in Southwest Houston. Ronquillo was president and founding member of the Ilocano Club. He was hosting the entertainers at the time. (Courtesy of Jerome Ronquillo.)

**Meeting of the Minds, 1979.** Members of the Ilocano Club conduct official business in an informal setting over a case of beer. Sitting in the shade are, clockwise from far left, Bobby Aquino, Romy Ronquillo, Ed Dimaala, Domie Perdido, unidentified, Buddy Galera, and George Bumanglag. (Courtesy of Jerome Ronquillo.)

**JOCELYN ENRIQUEZ AND GOODPHIL.** Pictured are, from left to right, Carmen Guevara, Glenda Santua, Michael Jumalon, early-1990s pop star Jocelyn Enriquez, Jennifer Jumalon, Michelle Jante, Robert Guevara, and Anthony Guevara at the GoodPhil 2000 After Party sound check at Texas A&M University, College Station. GoodPhil is a three-day competition held every March between the Filipino Students' Associations (FSA) of 12 universities and colleges in Texas. (Courtesy of Anthony Guevara.)

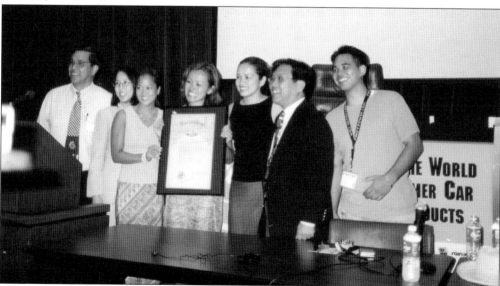

**FACOST PARENT AND YOUTH COMMUNICATION WORKSHOP, 2000.** At South Texas College of Law, a proclamation for PINAY Day was presented on August 26, 2000. From left to right are unidentified, Janella Del Mundo, and PINAY group singers Angelica Abiog, Maylene Briones, and Loredie Reyes, with Gordon Quan and Anthony Guevara. (Courtesy of Anthony Guevara.)

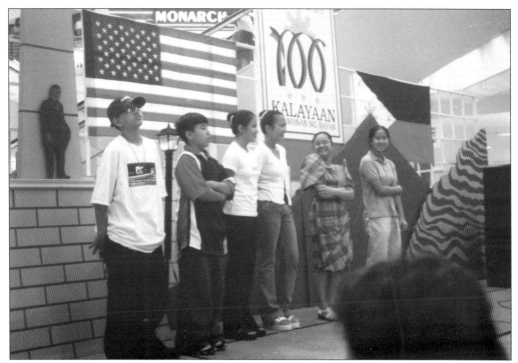

**KALAYAAN PHILIPPINE INDEPENDENCE.** *Kalayaan* translates from Tagalog to "liberty" or "freedom." A centennial celebration of Philippine independence was held in June 1998 at Sharpstown Mall with cultural dances, singers, and special guests. Robert Guevara (left) and other contestants are pictured participating in the Philippine history trivia contest. (Courtesy of Anthony Guevara.)

**A PRESIDENTIAL VISIT, 2000.** Philippine president Fidel Ramos visited Gold Ribbon Bake Shop for a little taste of home on March 15, 2000. Gold Ribbon was opened for many years at University Place. From left to right are Jody Chua, Johnny Allanigue, Ramos, Frank Guevara, Robert Guevara, and Anthony Guevara. (Courtesy of Anthony Guevara.)

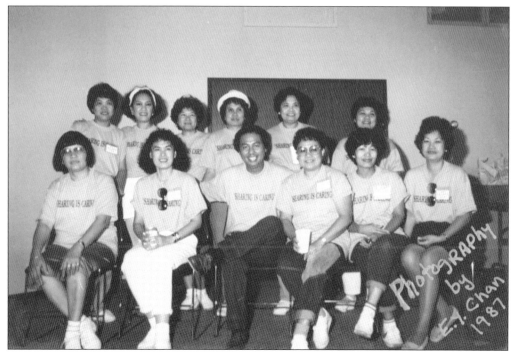

**PHILIPPINE NURSES ASSOCIATION OF METROPOLITAN HOUSTON (PNAMH).** Among those in this 1987 photograph are Mellie Zanders (front row, far left), the first instructor to help nurses pass their board exams, and PNAMH president Eufemia Chua (front row, third from left) at the Fondren Southmeadow clubhouse. PNAMH was formed on October 18, 1980. The group finished a walkathon to raise scholarship money for nurses. (Courtesy of Eufemia Chua.)

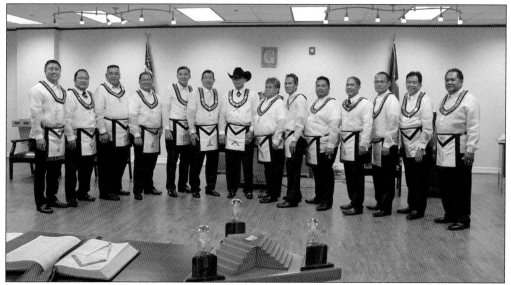

**SOLIDARITY LODGE NO. 1457 AF&AM.** Solidarity Lodge No. 1457 AF&AM is a Masonic lodge located in Houston under the Grand Lodge of Texas AF&AM. Chartered on December 4, 1993, it is the first Masonic lodge in Texas formed mostly by Filipino Masons. The 2017–2018 officers are pictured. (Courtesy of Stephen Aganan.)

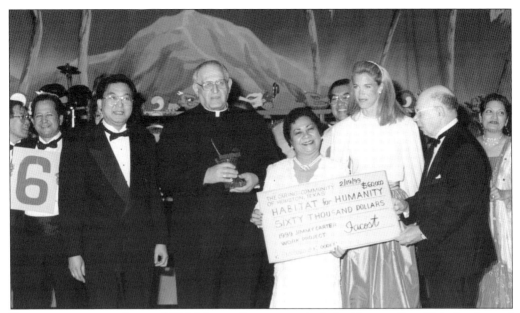

**FUNDRAISING FOR A CAUSE, 1999.** Norma Benzon received the Outstanding Civic Leader and Fundraiser award from Pres. Jimmy Carter in 1999 as the Habitat for Humanity kingdom builder. She is pictured holding a check from FACOST to the Habitat for Humanity projects in the Philippines next to Bishop Joseph Fiorenza. (Courtesy of Meredith Benzon.)

**INTERNATIONAL FOOD FESTIVAL, AUGUST 1986.** The Filipino Student Association held a food festival at the University of Houston Central Campus. Pictured are (first row) Neil Bascon, Cesar DeJesus, Patrick de la Paz, Bedo Castro, and Rick Chea; (second row) Noel Malcaba, Louis "Chito" Brotamonte, Jocelyn "Lani" Imperial , Myla Sylang-Cruz, Michelle Pineda Castro, Laarni Arceo, Gilda Ignacio Dimayuga, Eydene Gerona Sangel, Rowena Castillo, Pinky Digamon Concepcion, and Mark Caranto; (third row) Rhollie Pamilar, Jae Jong, and Carlos de Jesus. (Courtesy of Gilda Dimayuga.)

THE TEXAS ASSOCIATION OF PHILIPPINE PHYSICIANS (TAPP). TAPP was established in Houston in 1978. The organization has served to promote unity among the Filipino American doctors in Texas, particularly Houston, and its surrounding counties. Its first president was Dr. Rafael Chan. This photograph was taken at the 2008 inaugural, with Dr. Donna Duremdez as president. (Courtesy of Gilda Dimayuga.)

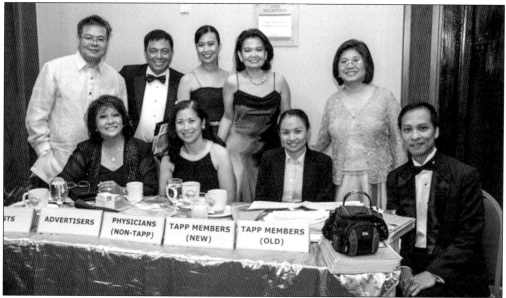

DOCTORS UNITE. TAPP has served to promote unity among the Filipino American doctors in Houston. It has also conducted multiple medical missions in the Philippines and, in collaboration with local charitable organizations, has been involved in numerous health-awareness projects in Houston. Pictured are past presidents of TAPP, taken during the 2008 inaugural. (Courtesy of Gilda Dimayuga.)

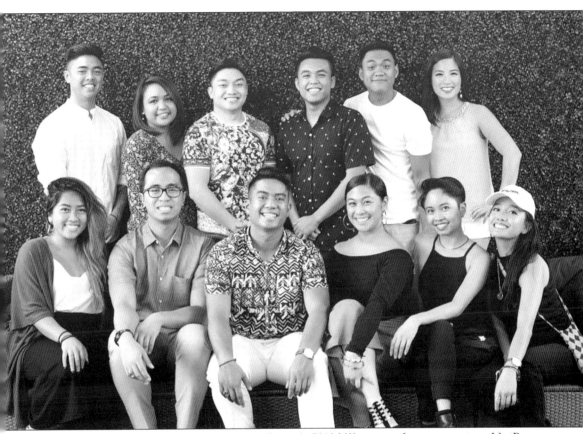

**Pilipino American Unity for Progress, Inc.** A 501(c)(3) nonprofit organization, UniPro originated in New York City in 2009 and expanded to cities such as San Diego, Seattle, and Chicago. The Texas chapter launched in September 2017, choosing to be named after the large state rather than a certain city. Its mission statement is as follows: "UniPro Texas aims to unite the Fil-Am community using our innate sense of Kapwa; through educating the public on our identity, we will thereby empower our people toward a brighter future. We seek to build a space for open communication between groups and generations, provide a medium for our voices to be heard." From left to right are (first row) Chanelle Billones, C.J. Velasquez, Mark Sampelo, Rea Sampilo, Jenah Maravilla, and Trisha Morales; (second row) Carlo Wayan, Alexandra Austria, Lord Miguel Macawili, Joshua Garcia, Michelouis Jao, and Rose Ann Aragon. (Photograph by Trisha Morales.)

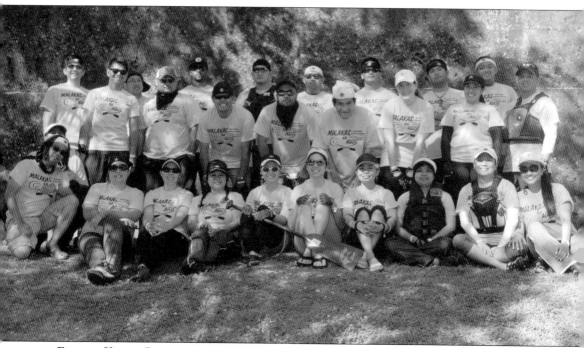

**FILIPINO YOUNG PROFESSIONALS (FYP) OF HOUSTON.** The first official group photograph of the team FYP Dragonboat, Malakas Na Agos, meaning "strong current," was taken at the Texas Dragon Boat Festival, on May 4, 2013, at Allen's Landing. The team was later renamed the FYP Island Warriors. Its website states: "Through its activities and events, FYP continuously ensures that its members, its friends and supporters in the local and global communities, and future generations will maintain Filipino cultural knowledge and awareness. FYP encourages its members to take an active role in educating themselves, and others, in the rich heritage and culture of the Philippines. FYP also provides its members with multiple opportunities to organize and participate in philanthropic initiatives benefiting the local and international community. Moreover, FYP holds frequent networking socials to foster an environment of friendship and promote professional relationships." FYP president Arnel Saludares is in the top left corner and founder Aubrey Garibay is in the bottom left corner. (Photograph by Mark Lester, courtesy of Aubrey Garibay.)

# Seven

# THE AMERICAN DREAM

## BEING A FILIPINO IN AMERICA

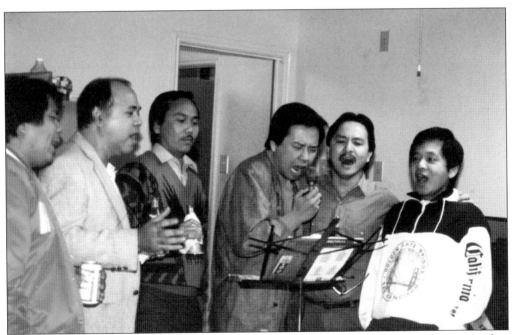

**THE AMERICAN DREAM.** During celebratory gatherings, one of the many activities enjoyed in a garage in Missouri City, a suburb outside of Houston, was the simple joy of singing together. Estanislao Suerte, Jun Sanchez, Fermin Arboleda, Bong Tiongco, Danny Seria, and Ben Marinas sing their hearts out. In the 1980s, families started to settle down and buy homes in the newly developed areas outside of Houston. (Courtesy of Rolando Panis.)

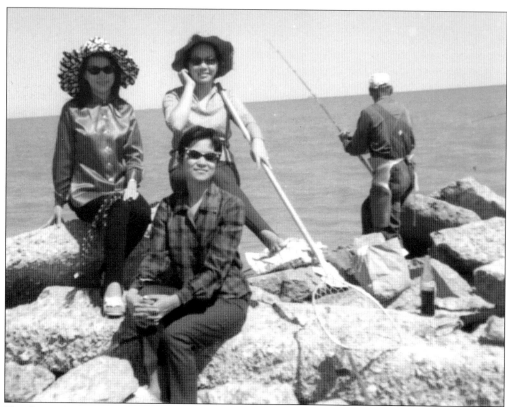

**THE JOY OF FISHING.** Fishing in Galveston, Texas, which is only an hour away from Houston, was a pastime for many Filipinos who settled in the city. Common spots for fishing included Seawolf Park, Freeport, Kemah, the Ferry Landing, Rollover Pass, La Porte, Sylvan Beach, and San Luis Pass. Most dried their fish, known as *daing, tuyô,* or *bilad;* cooked in a soup such as *sinigang,* or sliced and marinated as *kilawin.* Pictured from left to right, Rose De Los Santos, Edith Ronquillo, and unidentified observe fishermen on the rocks of Seawolf Park at Pelican Island. Manny Compas wears his cowboy hat while fishing on a pier with his son. (Above, courtesy of the Guevara family; below, courtesy of Louella Compas.)

**THE BIG CATCH.** Rolando Panis is pictured with his catch, a jackfish, which was not a game fish. Some fisherman did not care for this type of fish since it has red meat; most wanted white-meat fish only. The fish head was prized for use in sinigang. Panis shows the size of the fish in comparison to his son Joseph and his daughter Regina. (Courtesy of Rolando Panis.)

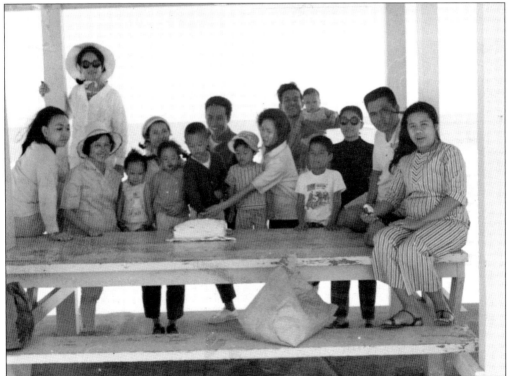

**A DAY IN THE SUN.** Families often spent afternoons at Galveston Beach, only an hour away from the bustle of Houston, as observed in this photograph taken in April 1970. The entire coastline of Texas, accessible to the public, provided the backdrop for many scenic vacation photographs as a way to get a taste of home. (Courtesy of Louella Compas.)

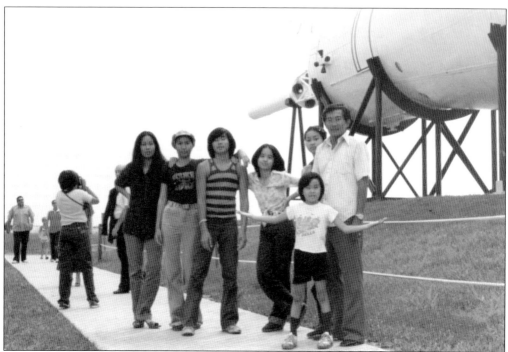

SPACING OUT. The Echiverri family transplanted from Chicago to Houston in 1979. The first place they visited was the National Aeronautics and Space Administration (NASA) Lyndon B. Johnson Space Center. Eddie Echiverri is pictured with his six children in front of one of the Saturn V rockets. (Courtesy of Lettie Echiverri.)

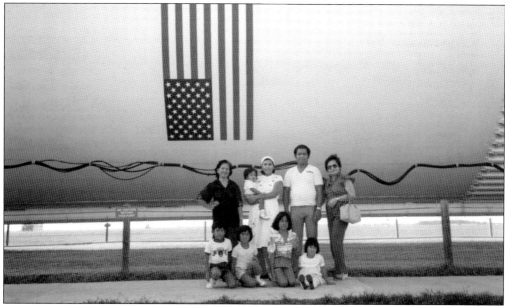

JOHNSON SPACE CENTER, 1984. The immensity of the Saturn V rocket at the NASA Space Center, along with many other exhibits on display, impressed out-of-town visitors. Rolando Panis (second from the right); his mother, Valeriana (far left); his wife, Violeta (middle); and his five children take a family friend on a tour of NASA's Johnson Space Center. (Courtesy of the Panis family.)

**HEIGHT OF THE SPACE RACE.** Rose De Los Santos (left) and Carmen De Los Santos pose in front of a lunar lander at NASA in the late 1960s. This was during the height of the space race to put a man on the moon and return him safely. On July 16, 1969, Apollo 11 launched to accomplish this mission. (Courtesy of the Guevara family.)

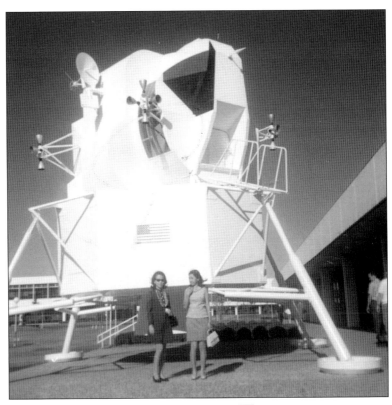

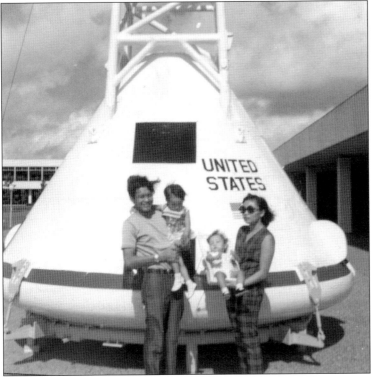

**EXPLORING HOUSTON, 1970.** Stepping right off the plane from the Philippines to America, the Compas family seemingly took no break to indoctrinate themselves into the Houston lifestyle by visiting Johnson Space Center, NASA. Pictured from left to right in front of a capsule are Manny Compas, Liezsl Compas, Arnell Compas, and Louella Compas. (Courtesy of Lieszl Compas.)

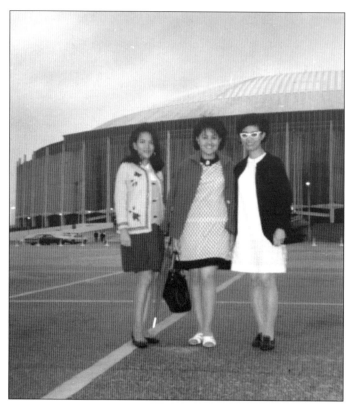

**ASTRODOME, 1970S.** The iconic Astrodome stadium opened in 1965. This was the city's most important structure at the time because of its signature domed structure and air-conditioning. From left to right, Rose De Los Santos (Guevara), Ched Lina, and an unidentified woman pose in their fashionable 1960s dresses attending a Houston Astros baseball game. In the photograph below, two-and-a-half-year-old Lieszl Compas stands on top of a 1970 Buick Skylark as the American flag waves. This was the first car bought by her parents, Manny and Louella Compas. (Left, courtesy of the Guevara family; below, courtesy of Louella Compas.)

**HOUSTON ZOO.** Newly immigrated to America, Manny and Louella Compas took their young daughters Lieszl and Miriam to visit Houston Zoological Gardens for the very first time in the summer of 1970. The Houston Zoo is located near the Houston Museum District and Hermann Park. (Courtesy of Louella Compas.)

**ASTROWORLD AMUSEMENT PARK.** Opening in 1968, Astroworld was a 75-acre amusement park with roller coasters and kiddie rides. With her daughters, Louella Compas stands in front of the park's welcome sign in the summer of 1970. Astroworld was later bought by Six Flags and was eventually closed and demolished in 2005–2006. (Courtesy of Louella Compas.)

**MECOM FOUNTAIN, 1970.** The Mecom Fountain, designed in 1964 by Eugene Werlin, was granted to the City of Houston by John W. and Mary Mecom. It is located in the roundabout where Main Street meets Montrose Street. Louella Compas is pictured with her mother, Nora Villamayor, and two children. The historic fountain was the largest fountain in Houston at the time and a popular backdrop for wedding and quinceañera photographs. (Courtesy of Louella Compas.)

**FAMILY BUSINESS.** The Bartolome family started a home health-care business in 1994. The business is run by their daughter Genevieve, who is pictured with her parents, Alfredo and Teresita, the first Filipinos in Seabrook. They came from humble beginnings, living in a trailer when they relocated from the Fondren area. They constructed the building by hand alongside their restaurant Pier Eight Seafood Fish Market. (Courtesy of the Bartolome family.)

**THE TRANSCO WATERWALL, 1980s.**
The name of the Waterwall was
changed to the Williams Waterwall
and ultimately to the Gerald D. Hines
Waterwall Park, in honor of Hines's
contribution to Houston architecture.
A centerpiece for Houstonians, the
Waterwall was a popular picnic spot in
the Galleria area. The Burgos family
is pictured enjoying a day in the sun.
(Courtesy of the Burgos family.)

**SANTA CLAUS, 1970s.** Christmas is a
holiday highly celebrated by Filipinos
for religious reasons. Usually only
one child sits on Santa's lap at a
time, but the whole Compas family
decided to make it a family activity.
Donned in his cowboy hat and
turtleneck, Manny Compas enjoys the
American tradition at Sharpstown
Mall after shopping with the family.
(Courtesy of Louella Compas.)

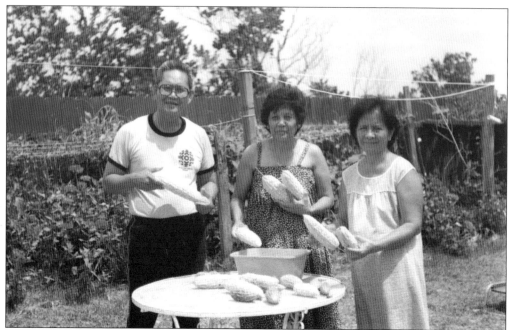

**HOMEGROWN.** Certain vegetables, such as ampalaya, or bitter melon, were not available in the local stores in the 1970s or 1980s. But the Houston weather provided a perfect climate to grow vegetables that reminded Filipinos of their homeland. Pictured are *lolo* (grandfather) Mario Sison and *lolas* (grandmothers) Leonor Sison and Valeriana Panis as they proudly show the latest harvest in Missouri City, a suburb of Houston. (Courtesy of Rolando Panis.)

**THE ILOCANO CLUB.** The Ilocano Club of Metropolitan Houston split from the Visayan Club after the Ilocano population grew large enough to form their own organization in 1981. The club is pictured at a get-together after practicing the *pananayan* dance. Members are, from left to right, Lerma Amaba, Norma Benson, Mila Galera, Gloria Jorque, and Tessie Bumanglag. (Courtesy of Tessie Bumanglag.)

**FOOD BRINGS PEOPLE TOGETHER, 1988.** Don Amancio (left), Filimar Blanco (center), and Ben Marinas came to the United States in the 1970s to join their wives and girlfriends who immigrated as Filipino nurses. They worked in accounting, civil engineering, and nursing. *Kambing* (goat), was cooked Ilocano style in a stew and served at parties. This photograph was taken in Sugar Land, Texas. (Courtesy of Rolando Panis.)

**THE LOLAS.** Pictured are, from left to right, (seated) Paring Chan, Lucia Corpuz Jarabata Torres, and Valeriana Panis; (standing) Conching Orencia and Prospera Panes. They are celebrating an event at the Panes house in Stafford, Texas. The lolas discuss community issues and reminisce on days of yore. Lolas were seen as mothers to many who did not have their own living with them in Houston. (Courtesy of Rolando Panis.)

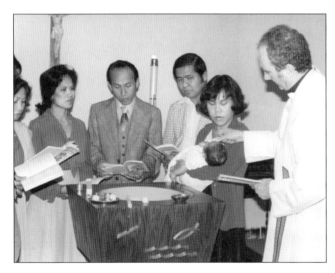

**HOLY FAMILY, 1980.** Godfather "Ninong" Rolando Panis oversees the baptism of Nannette Villamiel alongside godmother "Ninang" Patria Cillo and parents Doming, Lucy Villamiel, and Fr. Jay Walsh of the Congregation of St. Basil at Holy Family Catholic Church in Missouri City, Texas. Panis and Villamiel were neighbors in the Chasewood subdivision. Filipinos joined the parish when they moved during the development of Southwest Houston in the 1980s. (Courtesy of Rolando Panis.)

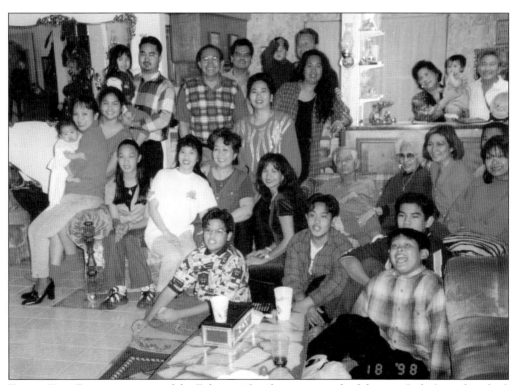

**FAMILY FUN.** Four generations of the Echiverri family are pictured celebrating Lola (grandmother) Josephine's birthday. Included in the photograph are Josephine's sons, the grandchildren with their spouses, their children, and great-grandchildren. (Courtesy of Dolly Echiverri.)

**DEBUTANTE, 2002.**
A debutante ball, or *debu*, signified the coming of age for 18-year-old daughters. A debut features 18 roses presented by 18 men in the girl's life, with a speech about a moment shared between the presenter and the debutante. Pictured at the Intercontinental Hotel ballroom are, from left to right, Kyle, Lester, Lauren, Marivic, and Drake Chapman. (Courtesy of Marivic Echiverri Chapman.)

**PERLAS NG SILANGAN, PEARL OF THE ORIENT.** The Perlas family founded the Perlas Ng Silangan cultural society. Their goal was to cultivate and promote Filipino traditional arts and culture among Philippine nationals and foreigners. The family is pictured during Geraldine Perlas's debut in April 1985. From left to right are Philip Perlas, Maybelle Perlas, Jay Patrick Perlas, Geraldine, Dr. Marylou Javier-Perlas, attorney Precy Perlas, and Veronica Perlas. (Courtesy of Maybelle Scharn.)

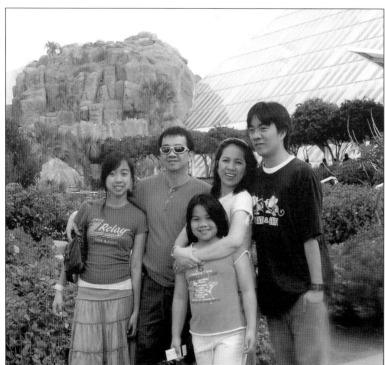

**MOODY GARDENS.** The Soriano family visited Moody Gardens when they first came to Texas in 2003. Moody Gardens is located in Galveston, Texas, a one-hour drive from Houston. Pictured are, from left to right, Keio, Bong, Keiko, Shei, and Keise. They are standing in front of the glass Aquarium Pyramid. (Courtesy of the Soriano family.)

**THANKSGIVING PLAY.** Families truly try to live the American dream when they settle in metropolitan Houston. Children enroll in local schools, participating in programs and plays, while parents are proudly ready with the camera. Lieszl Compas and Mark Caranto are pictured dressed up as Thanksgiving pilgrims in November 1975 at Grissom Elementary. (Courtesy of Louella Compas.)

**NEW CAR.** Rolando Panis proudly poses on his avocado green, lightly used 1972 Chevrolet Impala at the Driftwood Apartments on South Braeswood and Holcombe Boulevard near the Texas Medical Center, where he walked to pick up his wife, Violeta, who worked there as a nurse. People with surnames such as Benzon, Suerte, Blanco, Baterina, Soledad, Tadeo, Arboleda, and Amancio lived in the same complex. (Courtesy of Rolando Panis.)

**A GOLDEN ANNIVERSARY.** After 50 years of marriage, Valeriana and Francisco Panis renewed their vows at a ceremony in Notre Dame church in 1992. Valeriana came to the United States to help her sons raise their children. Francisco came to the United States to claim citizenship and benefits as a World War II veteran. (Courtesy of Rolando Panis.)

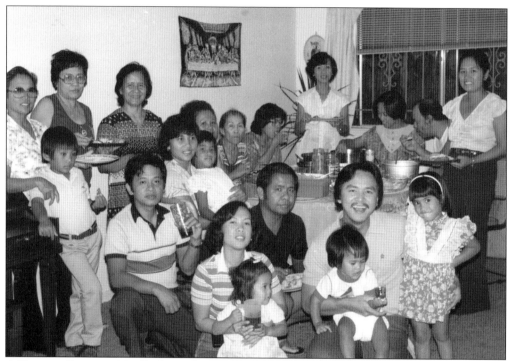

**A Feast of Family, 1983.** In the early 1980s, most Filipino families knew each other. In the small community, birthday parties were attended by practically everyone. Pictured are several families and generations: the Panis, Sanchez, Marinas, Dulyunan, and Seria families are represented. Families purchased their first homes in the newly developed southwest-area suburbs and were next-door or nearby neighbors. (Courtesy of the Panis family.)

**Texas Renaissance Festival.** The Balba family came to Houston in 2005. They attended the Texas Renaissance Festival for the first time in October 2014. The festival is an annual Renaissance fair located in Todd Mission, Texas, about 55 miles northwest of Houston. Edwin Balba is pictured with his wife, Ejoy, and children E.J., Joy, and L.J. (Courtesy of the Balba family.)

# *Eight*

# BUILDING FELLOWSHIP
## FIESTAS AND FIELD GAMES

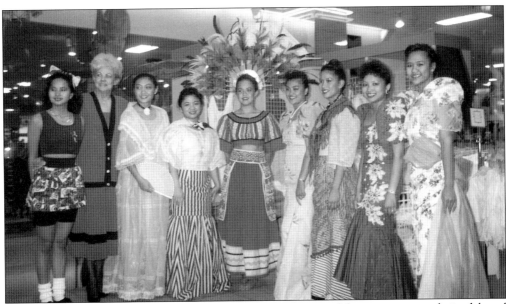

**FESTIVAL OF THE PHILIPPINES.** In May 1990, J.C. Penney, a national department store chain, debuted its newest clothing line, Festival of the Philippines. A fashion show at the J.C. Penney store at Meyerland Mall featured various styles of Filipino clothing. (Courtesy of Lieszl Compas.)

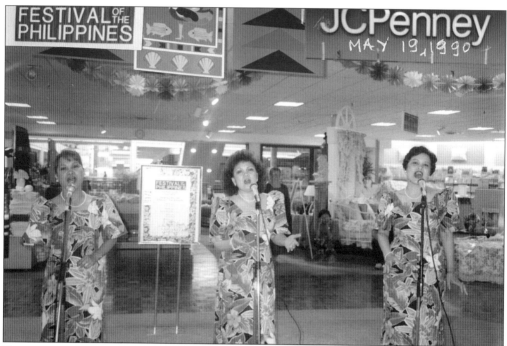

**PHILIPPINES INSPIRED, 1990.** A Philippine-inspired clothing line, mainly featuring children's clothing, launched at J.C. Penney stores in the summer of 1990. Pictured are the Starlites, local talents who toured around Houston J.C. Penney locations. In this photograph, they are performing "Power of Love" by Jennifer Ross in front of the store entrance in Meyerland Mall. Pictured are Linda Real (left), Louella Compas (center), and Naty Castro. (Courtesy of Lieszl Compas.)

**BINASUAN.** In the early 1970s, there was a small Filipino community that loved big gatherings. Keeping their homeland traditions alive, many performed traditional Filipino dances as entertainment during parties. Ben Del Puerto is pictured dancing here with his unidentified partner in the graceful balancing dance called *binasuan*. This Filipiniana party was held at the Warwick Hotel. (Courtesy of Louella Compas.)

"ANG BAKYA MO NENENG." Filipiniana showcases, as pictured, depicted not only folk dance but also cultural clothing and music. From left to right, Clem Ricafrente and Louella Compas are singing "Ang Bakya Mo Neneng," a song that describes a young woman's worn-out wooden clog. Ricafrente is wearing a man's traditional *barong*, and Compas is in a woman's *baro't saya*. (Courtesy of Louella Compas.)

KEEPING CULTURE ALIVE. As a way for Filipinos to connect to their homeland and educate their children on the culture, Filipiniana showcases were held, such as this one that took place in October 1971. Performances that include both traditional dance, like *tinikling* (pictured), and song paint a picture of what it means to be Filipino within the setting of America. (Courtesy of Louella Compas.)

SPANISH DANCING, 1973. Frank Guevara (left) is pictured with an unidentified partner at Warwick Hotel during a Filipiniana celebration for Filipino Americans of Metropolitan Houston (FAMH). Though it is important to showcase folk dancing indigenous to the Philippines, 300 years of Spanish colonization means their dances are part of the Filipino culture as well. (Courtesy of the Guevara family.)

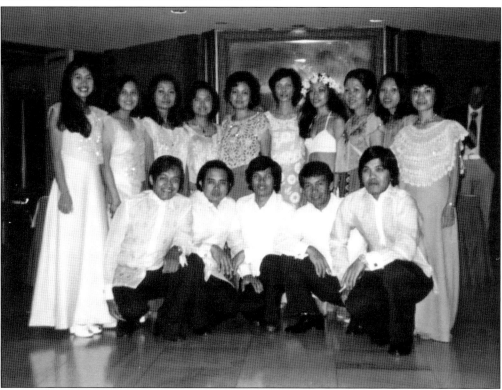

FILIPINIANA DANCE TROUPE. In 1971, Filipinos found ways to gather and spend time with other Filipino families. One way for fellowship was learning traditional Filipino dances and performing them during parties. Pictured here are the dancers who performed at the Warwick Hotel located near the Mecom Fountain. (Courtesy of Louella Compas.)

THE FIESTA-LOVING FILIPINO. Many Filipino events included traditional Filipino dancing. Michelle Ronquillo is pictured wearing a dress for one of the countryside dances, as described in a September 5, 1982, program for the Ilocano Club. The program describes the dances as "fast and lively, full of laughter and games." Ronquillo's family was one of the first families to come to Houston in the 1960s. (Courtesy of Jesusa Ronquillo.)

HARKENING BACK. The Filipiniana Dance Group, as pictured in September 1990, is made up of young Filipino Americans ages 10 to 18. According to an event script by Florencio Guinhawa, "this group believes that by joining our group they will have a sense of belonging and pride of something that is needed and really Filipino." (Courtesy of Florencio Guinhawa.)

**STRIKE A POSE.** An array of cultural dances were showcased by the Filipiniana Dance Group during a festival in September 1990. Binasuan is a dance requiring dexterity and poise. Filled glasses of water are balanced simultaneously on the dancers' heads and in their palms, as pictured here. (Courtesy of Florencio Guinhawa.)

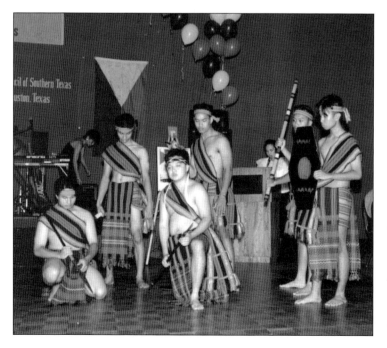

**KALASAG.** As the shield used by the Kalinga during battle, the *kalasag* is used in the corresponding dance as a percussion instrument and intimidation tactic. FACOST male members are pictured performing on Philippine Independence Day, June 1994, wearing traditional Kalinga tribal clothing. (Courtesy of Florencio Guinhawa.)

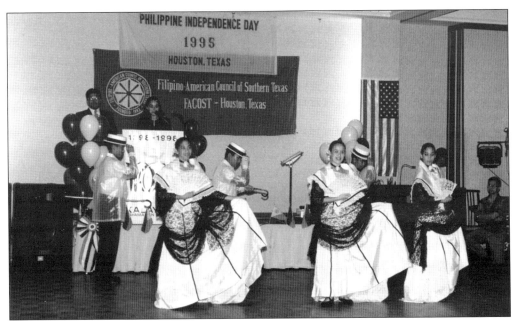

**FANNING THE FLAMES.** It is important for Filipinos to regard Spain's rule as an integral part of their past. FACOST female members are pictured wearing Maria Clara dresses, and the males are wearing *barong tagalog* during a performance on Philippine Independence Day in June 1995. This particular dance, *aray*, shows the courtship between the genders, with the women hiding behind the *abika*, or Spanish fan. (Courtesy of Florencio Guinhawa.)

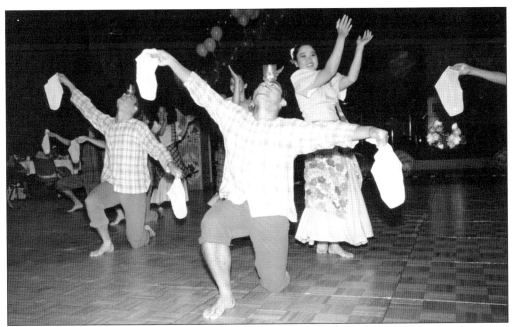

**LIGHT MY FIRE.** Filipino American Council of Southern Texas (FACOST) held its own showcases in commemoration of Philippine Independence Day, June 12, 1898, when the country successfully broke off from Spain's rule. Pictured in June 1994, *pandanggo sa ilaw* is being performed, where a lit candle is used in this partnership folk dance. (Courtesy of Florencio Guinhawa.)

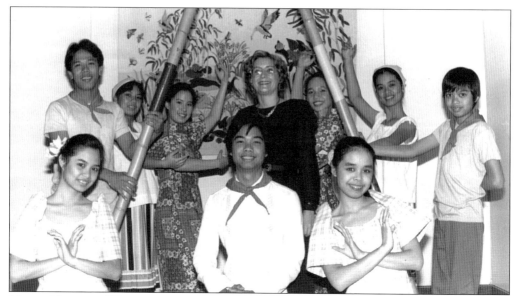

**MAYOR KATHRYN WHITMIRE, 1984.** Mayor Kathryn Whitmire is pictured with the Perlas Ng Silangan Cultural Group during its tinikling performance at the Consular Corps dinner dance on February 25, 1984. From left to right are (first row) Paula Paladio, Jay Perlas, and Gina Perlas; (second row) Alex Aguinaldo, Maritess Paladio, Eileen Jocson, Lanette Rosales, Maybell Rosales, and Phillip Perlas. Director Lizette Rosales and manager Marilou Javier Perlas, MD, oversaw the group but are not pictured. (Courtesy of *Manila Times*, Lizette Andreyko.)

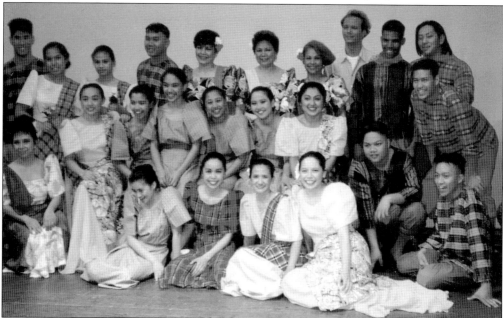

**PERLAS NG SILANGAN.** By 1986, Perlas had 75 active members and had performed in 100 cultural events in the Greater Houston area, such as the Asian American Festival, the Houston Arts Festival, and the Galveston Heritage festival. Lizette Andreyko (née Rosales), a former lead dancer of the Philippine Folk Arts group in Sydney, Australia, choreographed many of the dances. Dancers are pictured after a performance. (Courtesy of Lizette Andreyko.)

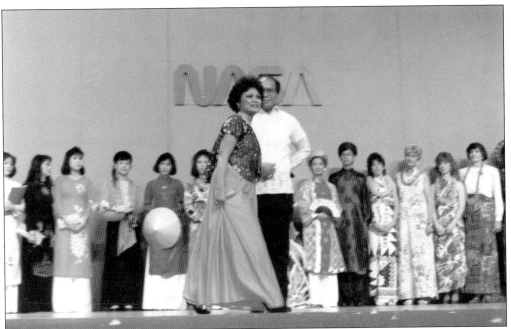

**INTERNATIONAL FASHION SHOWCASE.** The National Aeronautics and Space Administration's (NASA) Johnson Space Center hosted an international fashion show in the early 1990s. Pictured on a stage, lined up with other cultural costumes, are Louella Compas and Mel Ilagan, sporting a *kimona* shirt and *barong tagalog*, respectively. (Courtesy of Lieszl Compas.)

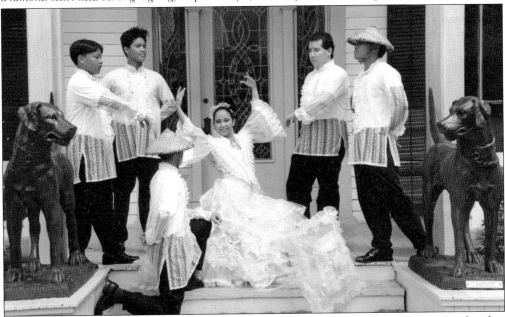

**PASEO DE ILOILO.** The Philippine Performing Arts Company, Perlas Ng Silangan, translated as "Pearls of the Orient," perform the Spanish dance *paseo de Iloilo* 1990. The dance is translated to "the walk of Iloilo," about courtship and winning the heart of the young lady. The performers are, from left to right, (first row) Christian Navarrete and Ruby Marquez; (second row) Jason Navarrete, Noel Castro, Daniel Marquez, and Franklin Real. (Courtesy of Estrelle Navarrete.)

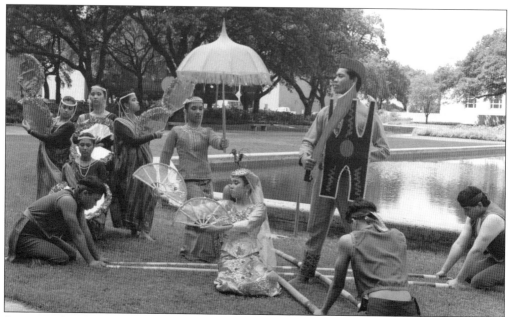

**SINGKIL.** The Philippine Performing Arts Company, Perlas Ng Silangan, performed the Muslim dance *singkil* around 1990. From left to right are performers (fan dancers) Leslie Sarmiento, Judelin Real Bonares, Angelita Lacsamana, and Ruby Marquez; (umbrella holder) Sheralin Real Salas; (princess) Nanette Lacsamana; and (prince) Noel Castro. The other kneeling performers are unidentified. (Courtesy of Estrelle Navarrete.)

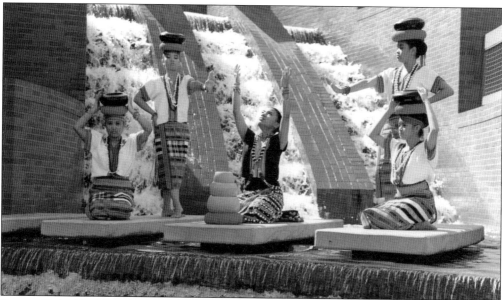

**BANGA.** Perlas Ng Silangan showcased many of the different cultures that influenced Filipino folk dance. This particular performance is of an Igorot dance called *banga*. Banga refers to the jars made of clay that sit upon the dancers' heads. The performers are, from left to right, Judelin Real Bonares, Nanette Lacsamana, Sheralin Real Salas, Angelita Lacsamana, and Leslie Sarmiento. (Courtesy of Estrelle Navarrete.)

116

**THRILLER NIGHT.** During induction balls in the 1980s, award ceremonies, or fundraising events, there was always an entertainment program. This young group performed to Michael Jackson's "Thriller." Pictured are (first row) Lieszl Compas; (second row) two unidentified, Emmanuel Bautista, and Gino Sobremesana. (Courtesy of Lieszl Compas.)

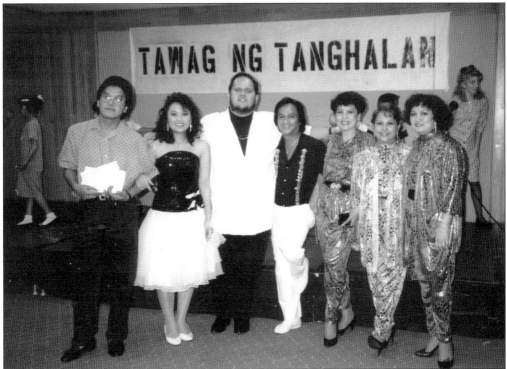

**TAWAG NG TANGHALAN.** Translated to "Call of the Stage," Tawag ng Tanghalan was a mid-1980s statewide singing contest that came to Houston in search of the next Filipino American star. The winner, chosen monthly, was to perform his or her own concert at the Ramada Inn. Pictured from left to right are Toty Concepcion, Beth Kasemi, Jake Garcia, Vic Concepcion, Naty Castro, Linda Real, and Louella Compas. (Courtesy of Lieszl Compas.)

**GIRLIE AND DABOYZ.** For many celebrations in the late 1980s through the 1990s, whether it be for weddings, graduations, anniversaries, or inductions of officers, this band was always sought out for its high energy, the vivacious voice of the lead singer, and precise musical technique. Band members are, from left to right, Patrick Dimayuga, Jess Ontoy, Girlie DeVera, Ron Musico, Dr. Gene Bacani, and Jorge DeVera. (Courtesy of Gilda Dimayuga).

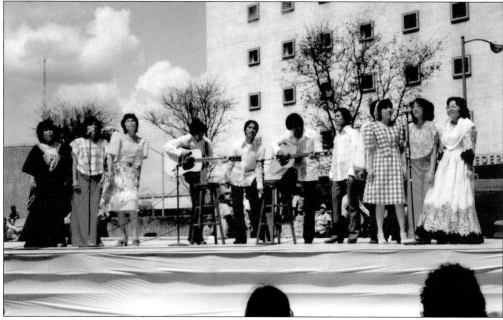

**HOUSTON FESTIVAL, 1982.** The group Mixed Emotions dressed in cultural dress to perform in downtown Houston's Tranquility Park on April 6, 1982. This was the first Filipino group to perform at the Houston Festival. The group was formed in December 1981, and reached a height in membership of 15 performers. (Courtesy of Louella Compas.)

**MIXED EMOTIONS.** The Filipino singing group performed in a disco dance and song fest on October 23, 1982. From left to right are Vicky Jugueta, Nesteeh Macasaet, Edith Dalina, Aldin Paradero, Robert Dalina, Afin Jugueta, Louella Compas, Jing Villamayor, Brenda Canlas, Eboy Villamayor, Lani Imperial, and Jojo Barroga. (Courtesy of Louella Compas.)

**MIX MASTER MANNY, DJ.** Donning his signature striped barong tagalog, Manny Compas stands as a contender for the (self-proclaimed) first Filipino DJ in Houston. Practicing his disc jockey skills from 1970 to 1990 and retiring in 2000, he has seen many celebrations around the city. Pictured are Manny Compas, Vincent Compas, Arnell Compas, and John Compas. (Courtesy of Lieszl Compas.)

**SOUNDS UNLIMITED.** The Serrano family made their debut at parties in the late 1980s. They brought a techno sound to the Filipino youth of Houston, playing artists such as Stevie B and Jocelyn Enriquez and keeping the young crowds dancing to the Hi-NRG music scene for hours. John Serrano (left) and Nilo Serrano are pictured getting ready to play the next set. (Courtesy of Nilo Serrano.)

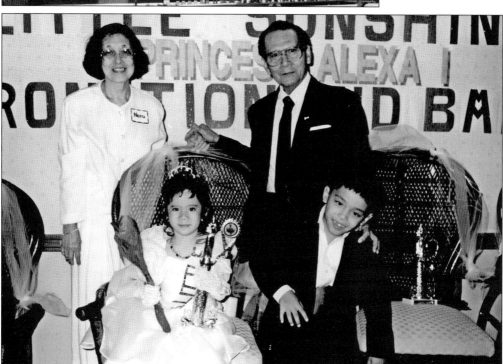

**MISS LITTLE SUNSHINE, 1994.** The United Senior Citizens Association of Texas (USCAT) hosted a coronation of Little Miss Sunshine on August 27, 1994, at the Holiday Inn Southwest Freeway. Grandparents Nora and Fred Villamayor oversee grandchildren Alexa Villamayor, posing with her tiara and trophy, and Riem Villamayor, her escort. (Courtesy of Louella Compas.)

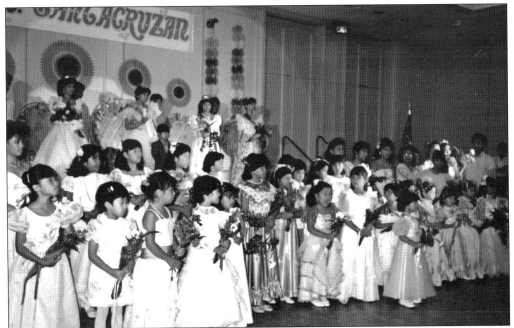

SANTACRUZAN, 1980s. "Santacruzan" is a pageant held during the month of May. It depicts the finding of the Holy Cross of Jesus Christ by Queen Helena (Reyna Elena), the mother of Constantine the Great, who ended the persecution of Christians. The photograph shows the court of Reyna Elena at St. Vincent de Paul Catholic Church, sponsored by the Filipino American Society of Texas (FAST). (Courtesy of Lieszl Compas.)

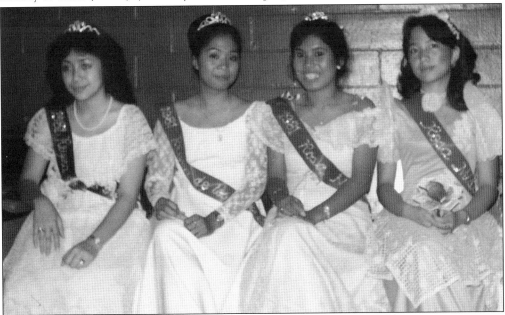

SANTACRUZAN. Filipino Americans of Metropolitan Houston (FAMH) held a Santacruzan event at St. Vincent Catholic Church in 1981. During Santacruzan, different biblical figures, personified as queens, or *reynas*, are paraded in procession. Pictured from left to right are Cecille Barroga, Chame Bautista, Lani Imperial, and Lovette Rosales. (Courtesy of Minda Bautista.)

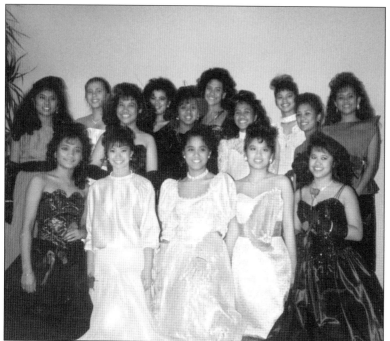

**Ms. Sweetheart Contestants, 1989.** Filipino Americans of South Texas Enthusiastic and Supportive Teens (FASTEST) held their second-annual Ms. Sweetheart pageant at the Crowne Plaza Hotel. The pageant was so named because it took place around Valentine's Day. The contestants pictured are seen sporting the latest fashion and hairstyle trends of the time. (Courtesy of Yvonne Remo.)

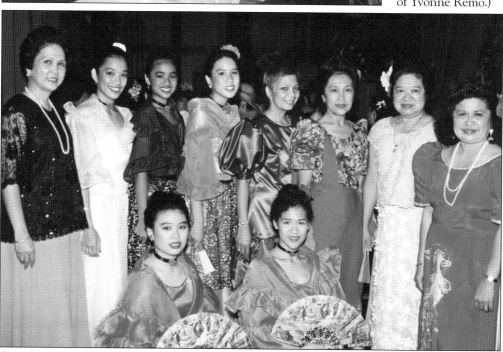

**Cultural Presentation, 1980s.** FAMH held a ceremony showcasing Filipino folk dances. Though many festivals included folk dancers, this one in particular was a formal event, asking the audience members to dress in their best Filipiniana. Pictured from left to right are Alice Chancoco, Ianne Perez Quila, Debbie Diza, Janella Del Mundo Gee, Adalea Palec, Minda Bautista, Susie Ronquillo, and Perla Crisostimo. The fan dancers are Emma Chua (left) and Cora Bautista-Vu. (Courtesy of Minda Bautista.)

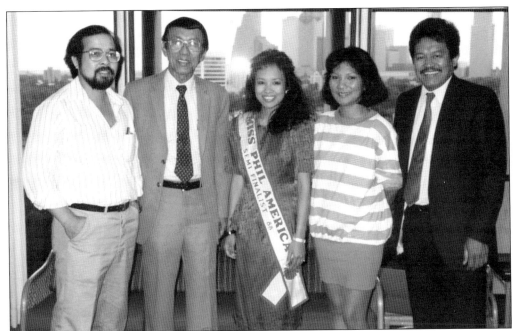

**MISS PHIL AMERICA.** Mutya ng Pilipinas, or Muse of the Philippines, is an annual national pageant. The winner of the pageant then competes in Miss Philippine America, amongst other such honors. In this photograph, Liezl Compas (wearing sash) meets with the consulate general of the Philippines. Pictured from left to right are Ding Alfuente, unidentified, Compas, unidentified, and Manny Compas. (Courtesy of Dolly Echiverri.)

**FASHION SHOW, 1991.** Filipino American of South Texas Enthusiastic and Supportive Teens (FASTEST) helped engage the teenage Fil-Am demographic by holding events they were interested in, such as this fashion show held at the Westin Galleria. Pictured in the white skirt is Dolly Echiverri. (Courtesy of Dolly Echiverri.).

FASHION SHOW, 1988. Annually, Filipino American of South Texas Enthusiastic and Supportive Teens (FASTEST) held its fashion show at various venues around Houston. This one took place at the Crowne Plaza Hotel in the River Oaks area. The participants pictured are posing enthusiastically in their 1980s looks. (Courtesy of Yvonne Remo.)

GETTING READY. This photograph offers a backstage view of the Filipino American of South Texas Enthusiastic and Supportive Teens (FASTEST) fashion show, with the girls getting ready amongst piles of ready-made outfits and big hair. Pictured from left to right are (first row) Yvonne Remo, unidentified, and Lesley Bacero; (second row) Mahin Gaytos, Mary Ann Aurelio, and Chitty Cruz. (Courtesy of Yvonne Remo.)

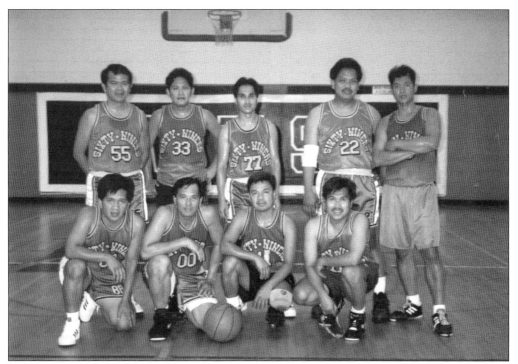

**SIXTY-NINERS.** Many Filipino athletes, young and old, joined the Philippine American Sports Association basketball league in the 1990s. Their tournaments were held at Westchester High School in West Houston. Pictured from left to right are (first row) Edgar Lacro, Ramir Antolin, Fred Marcial, and Ramon Paguio; (second row) Rey Mudlong, Danny Jardiolin, Nilo Paguio, Gary Manalo, and Bob Boado. (Courtesy of Gilda Dimayuga).

**KARILAGAN CHAMPIONS.** Pictured in the 1980s are the championship winners of a basketball tournament bearing the name Karilagan, which translates to "Awesome." The team was sponsored by Lourdes Dumlao, owner of the Karilagan Travel Agency. The agency specialized in the placement of many nurses and physical therapists to Houston. (Courtesy of the Dumlao family.)

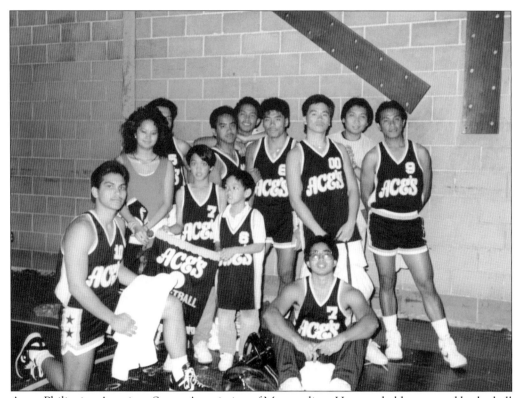

ACES. Philippine American Sports Association of Metropolitan Houston held an annual basketball league in the 1980s. At the start of each season, PASAMH showcased a parade of teams at the opening ceremonies. Each team marched in, with players dressed in their uniforms, along with their muse and their mascot. Members of the Aces team are pictured here after the opening ceremonies. (Courtesy of Lieszl Compas.)

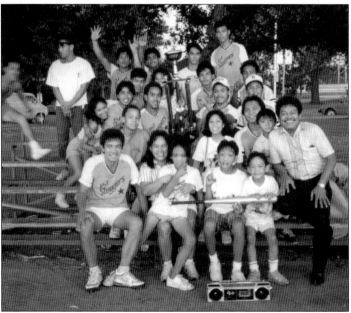

SLUGGERS. Philippine American Sports Association of Metropolitan Houston held an annual softball league in the 1980s. Teams played in the hot Texas summers at Linkwood Park. Softball tournaments were great gatherings for family and friends. This photograph was taken of the Sluggers after they won the championship game. Pictured at bottom left, Lorenzo Tatlonghari was head coach of the Sluggers. (Courtesy of Lieszl Compas.)

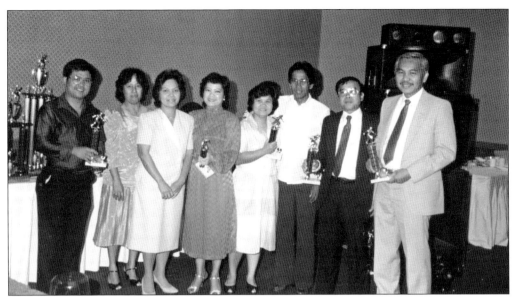

BOWLING AWARDS NIGHT. Emerald Bowl, located at 9307 Boone Road in Houston, proudly hosts the local Filipino American bowling league once a week. Pictured during one particular awards ceremony in the 1970s are, from left to right, Bert Daduya, unidentified, Nora Garcia, Angelita Vinaluan, Tessie Bumanglag, George Bumanglag, and two unidentified. (Courtesy of Tessie Bumanglag.)

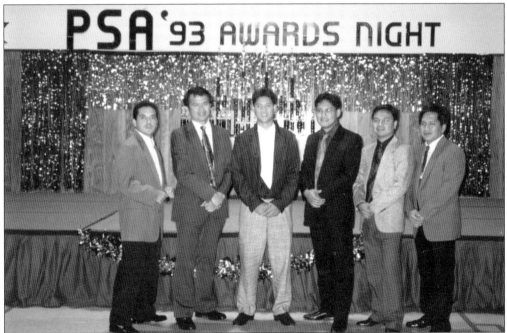

PSA AWARDS NIGHT. Many people were involved in their community through sports leagues as a way to maintain camaraderie, fitness, and friendly competition among athletes. Pictured here are officers of one of the Philippine American Sports Association basketball teams called Sixty-Niners during Awards Night and Installation of Officers in 1993. From left to right are Patrick Dimayuga, Rey Mudlong, Bob Boado, Danny Jardiolin, Fred Marcial (president), and Edgar Lacro.

# DISCOVER THOUSANDS OF LOCAL HISTORY BOOKS FEATURING MILLIONS OF VINTAGE IMAGES

Arcadia Publishing, the leading local history publisher in the United States, is committed to making history accessible and meaningful through publishing books that celebrate and preserve the heritage of America's people and places.

Find more books like this at
## www.arcadiapublishing.com

Search for your hometown history, your old stomping grounds, and even your favorite sports team.

Consistent with our mission to preserve history on a local level, this book was printed in South Carolina on American-made paper and manufactured entirely in the United States. Products carrying the accredited Forest Stewardship Council (FSC) label are printed on 100 percent FSC-certified paper.

MADE IN THE USA